REMEMBERING THE
SULLIVAN COUNTY
CATSKILLS

REMEMBERING THE
SULLIVAN COUNTY
CATSKILLS

JOHN CONWAY

Charleston | London

THE
History
PRESS

Published by The History Press
Charleston, SC 29403
www.historypress.net

First published 2008

Manufactured in the United States

ISBN 978.1.59629.584.1

Conway, John, 1952-
Remembering the Sullivan County Catskills / John Conway.
 p. cm.
ISBN 978-1-59629-584-1
1. Sullivan County (N.Y.)--History--Anecdotes. 2. Sullivan County (N.Y.)--History, Local-
-Anecdotes. 3. Sullivan County (N.Y.)--Biography--Anecdotes. 4. Sullivan County (N.Y.)-
-Social life and customs--Anecdotes. 5. Catskill Mountains (N.Y.)--History--Anecdotes.
6. Resorts--New York (State)--Sullivan County--History--Anecdotes. 7. Resorts--New
York (State)--Catskill Mountains--History--Anecdotes. 8. Outdoor recreation--New York
(State)--Sullivan County--History--Anecdotes. 9. Outdoor recreation--New York (State)--
Catskill Mountains--History--Anecdotes. I. Title.
F127.S91C659 2008
974.7'35--dc22
 2008038822

Notice: The information in this book is true and complete to the best of our knowledge. It is offered without guarantee on the part of the author or The History Press. The author and The History Press disclaim all liability in connection with the use of this book.

CONTENTS

INTRODUCTION

There was nothing to suggest when the first "Retrospect" article ran in July 1987 that the column would have a long life, and yet here it is, more than twenty years later, still going strong. Although the column has changed somewhat from those early years, one thing has remained constant: the attempt to accurately and vividly recount the rich and colorful stories of the people, places and events that make up the history of the Sullivan County Catskills.

"Retrospect" has touched on a wide variety of topics over the years, from heinous crimes and despicable criminals to war heroes and enterprising women; from innovative resorts and sprawling railroads to unusual industries and harebrained business schemes; and from serious statesmen and aspiring politicians to whimsical characters and village idiots.

I have attempted to gather together some of my personal favorites in the pages that follow. Given that there were over one thousand columns to choose from, that was not an easy task. In an attempt to make the process somewhat less daunting, certain criteria needed to be adopted. For example, columns that were included in the earlier compilation of "Retrospect" (1996) were not considered. Neither were columns on subjects covered in my other books. Hence, no columns on Dutch Schultz or the Loomis Sanitarium appear here. Finally, columns on organized crime in the Catskills, a subject that will be treated in considerable depth in my next book, were eliminated from consideration.

I have attempted to present columns with a broad appeal, and I hope I have included at least some of your favorites, too.

PART I

FAMOUS NAMES

CHARLES ATLAS

D ecades before the Laurels Country Club on the shores of Sackett Lake became famous as the hippest of all hotels in Sullivan County—and the first Jewish resort to offer lobster on its menu—the lake was known for its tranquil beauty and for the way, according to one promotional brochure, it glimmered "as with millions of rubies in the red glow of the sinking sun."

Originally named for Ananias Sackett, who discovered it while clearing the first improved road into the county for the Livingston family, the lake was known as Sackett's Pond until the late nineteenth century, when, with the beginning of the tourism boom, virtually all the "ponds" in Sullivan County became "lakes" overnight. As far back as 1872, Hamilton Child noted in his *Gazetteer and Business Directory of Sullivan County* that the "quiet and attractive scenery…is becoming appreciated by the lovers of the beautiful in nature, and those who seek a retreat from the heat and dust of the cities in summer, and a brief respite from the cares and perplexities of business."

It was that same quiet and natural beauty that brought health and fitness guru Charles Atlas to Sackett Lake in the 1920s.

Atlas was not only the "World's Most Perfectly Developed Man," but he was also chosen by *Forbes* magazine as one of the twentieth century's "Super Salesmen" and by the *New York Times Sunday Magazine* as one of the most influential men of the century.

His innovative system of bodybuilding exercises, called "Dynamic Tension," changed the lives of hundreds of thousands of youngsters throughout the world. He won his "Most Perfectly Developed" title—and

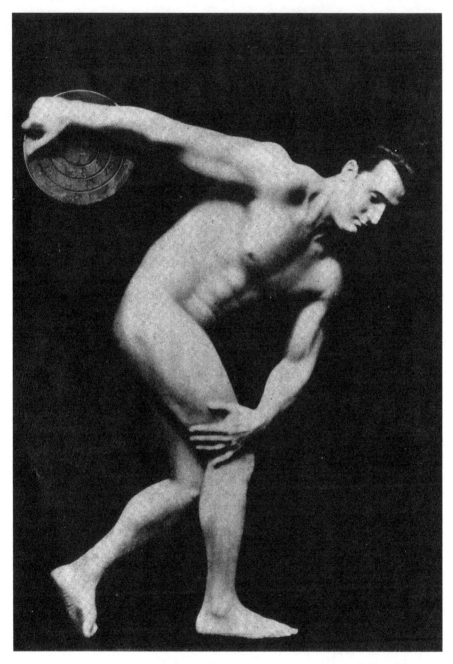

An ad for the physical fitness camp that Charles Atlas ran at Sackett Lake in the 1920s.

$1,000 in cash—in a contest sponsored by health guru Bernarr Macfadden at Madison Square Garden in 1921. He used his winnings to open a mail-order business to sell his training secrets the following year, and after a second win in 1922, he began a summer camp in Sackett Lake, which he ran into the early 1930s.

"In my search for a truly ideal location for my Physical Culture Camp, I finally selected beautiful Sullivan County," Atlas wrote in 1926. He continued:

> *This was chosen because of its wonderful, healthful climate: so high and dry, the air so invigorating and refreshingly pure. The entire country is particularly free from mosquitoes, insects, and dangerous snakes. The gorgeous scenery of the surrounding district is marvelously lovely, rivaling the beauties of Switzerland. Its perfect highways and nearness and convenience to New York City makes it doubly attractive. I know of no finer spot in all of America than the delightful Sullivan County.*

Atlas wrote that the county had it all: "mountains, dales, running brooks, its abundance of lakes, while its network of new state roads makes camping or touring a real pleasure."

He boasted that he had entertained over two hundred campers at Sackett Lake during the summer of 1925, and "not one of them was sick, and those who were suffering when they came, all quickly recovered."

That is not to say that the camp was a financial success. In fact, Atlas's business enterprises mostly foundered until late in 1928, when he formed a partnership with advertising executive Charles Roman. The pair formed Charles Atlas, Ltd. in 1929, and the partnership lasted until 1970, when Atlas sold his shares to Roman and retired. It was Roman who developed the world-famous cartoon ads featuring the ninety-seven-pound weakling "Mac" and the sand-kicking bully. But Atlas was the undisputed star of the show.

Born of Italian heritage in 1893 (though accounts differ as to his place of birth—some say Calabria, Italy, while others say Brooklyn), Angelo Siciliano was a frail youth who left school at fifteen to work in a pocketbook factory. After being humiliated on a Coney Island beach when a bully kicked sand in his face, he became obsessed with building up his body. Disappointed with the results that weightlifting at the local YMCA was producing, Siciliano devised his own system of working one muscle against another after observing a lion stretching at the Prospect Park Zoo. The results were phenomenal. From 1916 to 1921, he was one of the nation's most popular male models,

posing for, among other things, over forty statues, including one of George Washington in New York's Washington Square, and another of Alexander Hamilton at the Treasury Building in Washington, D.C. He legally changed his name in 1922.

By that time, he had won his two contests and had formed the Physical Culture Institute, headquartered at 1755 Broadway and Fifty-sixth Street in Manhattan. The summer camp at Sackett Lake grew out of that enterprise. It epitomized Atlas's holistic approach to physical fitness, a concept he undoubtedly picked up as a devout reader of Macfadden's *Physical Culture* magazine. Interestingly, Macfadden would have his own link to Sullivan County history, purchasing the failing Loomis Sanatorium near Liberty in 1938 and operating it until 1942.

By 1940, Atlas and Roman had turned their fledgling enterprise into a multimillion-dollar business, with offices in London, Rio de Janeiro and Manhattan. When World War II created a new impetus for physical fitness, the company benefitted, and by 1942 over 400,000 copies of the "Dynamic Tension" program had been sold worldwide.

Through it all, Charles Atlas remained a private, simple man, living a quiet life in Point Lookout, Long Island. He died of a heart attack on December 23, 1972. Charles Atlas, Ltd., however, continues to prosper, and the Atlas name is still a viable trademark. Along with the Dynamic Tension program, the company now offers dietary supplements and Atlas apparel. But nostalgia is a big part of the draw, too, and the famous "Mac" cartoon ads are still run.

The Sackett Lake camp has not been forgotten, either. Jeffrey Hogue (CEO of Charles Atlas, Ltd.) said that photos from the camp are on display at the Smithsonian. He said he recently received a letter from a gentleman who attended the Physical Culture Camp and another from a man who had worked as a counselor there.

George M. Beebe

It is arguable that no man in the annals of Sullivan County history ever achieved so much as George Monroe Beebe, and yet you are forgiven if you are not familiar with the name.

Those who over the years have written so ably about the county's past have not dwelled on his accomplishments. Manville B. Wakefield mentioned him not at all. James Eldridge Quinlan, who throughout his *History of Sullivan County* maintained that "it is not the province of the local historian to write

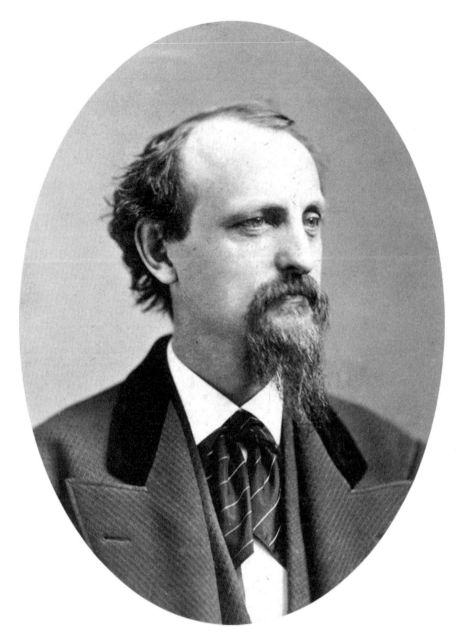

George M. Beebe, newspaperman, orator, governor. *Courtesy of the Monticello F&AM Lodge #532.*

freely of the living," affords Beebe but one sentence. Only Hamilton Child, who published *The Gazetteer and Business Directory of Sullivan County for 1872–73*, provides so much as a clue to Beebe's station in life. Child lists Beebe as the owner and publisher of the *Republican Watchman* newspaper, and, in a footnote, praises him for allowing John Waller, the publisher of a rival paper (the *Sullivan County Republican*), to use the *Watchman's* printing press when the Republican offices were destroyed by fire in 1872.

Edward F. Curley, in his book *Old Monticello*, refers to Beebe as a "well known and highly respected citizen" of the village, but declines to elaborate, noting that "anything I might say regarding him would be of little avail."

Indeed, Beebe was the owner and publisher of the *Republican Watchman* from 1866, when he purchased it from Quinlan, until 1895, when he sold the paper to Adelbert M. Scriber and Charles Barnum. During his tenure as newspaperman, he served in the New York Assembly, the U.S. Congress and as a judge in the Court of Common Claims. But George M. Beebe's greatest accomplishment came years before all of that.

Beebe became governor of Kansas in 1860, at the age of twenty-three.

He was born in New Vernon, in Orange County, on October 28, 1836, the son of Elder Gilbert Beebe, a well-known Baptist preacher who later published the nationally distributed Baptist newspaper, *Sign of the Times*. George attended public school and the Wallkill Academy in Middletown. Following his graduation, he moved to Monticello, where he studied law in the office of prominent local attorney George W. Lord. Beebe received his law degree from Albany Law School and was admitted to the bar in 1857.

That same year, he went west, according to Alvin O. Benton in his 1942 book, *Early Masonry in Monticello and Sullivan County*, and became editor of the *Central Illinois Democrat*, "a daily paper published in the city of Peoria." He worked on Stephen Douglas's reelection campaign against Abraham Lincoln in 1858, and then moved to Troy, in the Kansas Territory, to practice law. Just one year later, he was elected to the territorial council, and in 1860, he was appointed secretary of the territory by President James Buchanan. A few months later, he was governor, a post he held when Kansas was admitted to the Union amid much turmoil in 1861.

Benton relates that

> one day when the boy Governor was sitting in his executive mansion communing with his thoughts, a party of United States and territorial officers called to see the new Governor. He showed them about his mansion; delighted them with their apostrophies [sic] on Kansas and they praised his hospitality. "Well, Governor," said one of the Washington visitors, "you

seem to be nicely situated here, but where is your library?" "Right this way," replied Governor Beebe. They passed through one room into another and the Governor closed the door softly, much to the mystification of his visitors. "There!" said the Governor, pointing to a farm almanac, "There is my library!"

Beebe served as a delegate to the North-South peace convention in Philadelphia in 1861 and became the law partner of Albert H. Horton, who later served as chief judge of the Kansas Supreme Court. Before long, he had relocated his practice to St. Joseph, Missouri, and then to Virginia City, Nevada. In 1865, he ran unsuccessfully for associate judge on the Nevada Supreme Court, and following his defeat was appointed internal revenue collector for the state by President Andrew Johnson. He resigned that position to return to Monticello, where he purchased the *Republican Watchman* newspaper in 1866.

Beebe was defeated in his run for the New York Senate in 1871, but he was elected to the assembly in 1872 and 1873. Benton wrote that he was "quickly recognized as the orator of the Assembly and his common sense, social qualities, and oratory made him a commanding figure among his legislative associates." By that time, Beebe had become master of the Monticello Lodge No. 532 of the Free and Accepted Masons, a position he filled ably.

Beebe was elected to Congress in 1874 and again in 1876, serving as chairman of the Committee on Expenditures in the Department of the Navy and of the Committee on Mines and Mining. He unsuccessfully ran for a third term in Washington in 1878. He served as a delegate to three Democratic National Conventions and was appointed a judge of the New York State Court of Claims by Governor Grover Cleveland in 1883. He served in that capacity until his retirement from public life in 1900.

By then, Beebe had sold his interest in the *Republican Watchman* and had moved to Ellenville. He died there on March 1, 1927. He's buried in Woodlawn Cemetery in Newburgh.

CHESTER W. CHAPIN JR.

Chester W. Chapin Jr.'s estate was larger by far than any other in Sullivan County history. He was a multimillionaire industrialist, banker, steamship and railroad magnate and an avid sportsman who was a crack shot. He helped win the America's Cup in 1893 and held the world's record for sailing from New York to Cadiz in his own yacht, *Yampa.*

His father, Chester William Chapin Sr., was a self-made man, the youngest of seven children, whose father died while he was still a young boy. The elder Chapin went from a childhood of arduous labor to become the wealthiest resident of Springfield, Massachusetts. He was the founder and president of a steamship line, several railroads and a number of banks, and was director of two insurance companies. When he died in 1883, he left an estate valued at over $2 million.

The younger Chapin quickly outdid his famous father. He expanded the steamship line, founded new railroads and entered into development projects in the Western United States that yielded big profits. In 1889, just a few months after he had sailed the *Yampa* to Spain, he visited Sullivan County on a hunting trip and was taken by the rugged natural beauty of the area. A devout conservationist at heart, he was offended by the devastation that the tanning and quarrying industries had wrought here. Where once had stood stately evergreen forests, dried-out scrub grew unabated. Laurel and rhododendron, once plentiful, had become hard to find. Within two years, he had begun purchasing the mostly small parcels of land that would eventually make up the twenty-thousand-acre preserve he called Chapin Park.

Chapin spent as little as fifty cents an acre for some of the property and as much as fifty dollars an acre for other pieces. He fenced off over five thousand acres to enclose a herd of white-tailed deer, at that time all but hunted to extinction here. (In fact, by 1892, deer had become so scarce here that hunting was prohibited for five years.) In another section, he housed elk shipped in from near his ranch in Colorado. It was long believed by some that he created the massive preserve specifically to house a gift he had been given of twelve elk, but that story, while plausible, is likely apocryphal. Other sectors of the preserve were stocked with grouse, rabbits and varied small game. Fences were designed not only to keep these species enclosed, but also to protect them from the predators that prowled the land, wildcats, foxes and raccoons among them.

The four lakes on the estate—Lebanon, Cliff, Long and Ayers—were stocked with fish. Pickerel, perch, bullheads and trout were found in great abundance on different parts of the property.

Not all the animals on the estate were there for the hunting. Chapin also owned Normandy cattle, Arabian horses and Belgian hare, as well as sheep, chickens and a number of dogs. His gardens produced peas, carrots, rutabagas, onions and potatoes. In 1895, one of Chapin's cattle won first prize at the Sullivan County Fair.

In 1897, Chapin began construction of Elk Lodge, a project that took eighteen months to complete. Although designed as a rustic hunting lodge,

the Victorian shingle-style residence lacked not a single luxury. Built almost entirely of native oak and bluestone, with a cypress roof, it stands virtually unchanged to this day. One of the nine wells on the property supplied a cistern in the attic of the lodge, which in turn fed the entire house via gravity. It was one of the first residences in the county to be wired for electricity and telephone.

Chapin's extensive property often served as a target for local vandals. In April 1903, an arsonist started a fire on the estate that soon spread through nearby Glen Spey.

"About two-thirds of the place, which comprises 20,000 acres, have been burned over," the *New York Times* reported. "Mr. Chapin has offered a reward of $2,000 for the conviction of the person who started the fire."

The *New York Times* continued: "Flames are sweeping over the Mackenzie estate, a short distance [from] here, and are being carried by the wind to the village of Glen Spey, where the eight children of the late George R. Mackenzie of New York City have fine summer homes."

Poachers were a constant problem, too. In November 1903, Chapin Park employee William Shiells was shot while trying to stop three poachers (who escaped). Shiells, whose left arm was seriously wounded by the shotgun blast, was rushed to a house on the property, where the bleeding was stemmed enough to get him to Pond Eddy and by train to the hospital in Port Jervis. Chapin offered a $1,000 reward for the capture of the poachers, and local law enforcement officials made quick arrests, only to find out that they had apprehended the wrong men.

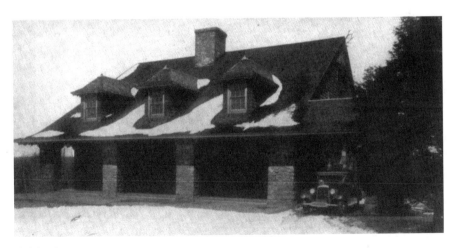

Elk Lodge on Chester W. Chapin Jr.'s estate.

Chapin was quite the ladies' man. Extremely handsome, though diminutive, he is remembered for the mischievous twinkle in his eye. He married his first wife, Emelia, when they were both twenty-five, and they had two daughters. Emelia filed for divorce for unspecified reasons sometime around 1900. He married his second wife, Elizabeth, who was his cousin, in 1906. She was twenty-five.

In 1912, a New York City widow named Janet H. Phillips filed a lawsuit against Chapin, the nature of which was initially concealed. Although the woman's lawyer told the *New York Times* that the matter involved a package of letters written by Chapin to the woman, and hinted that it was over a breach of promise of marriage, nothing more was ever made public. The matter was settled out of court. Chapin was seventy-one years old at the time.

Chester W. Chapin Jr. died in 1922, at the age of eighty-one, leaving an estate estimated at $5 million. A complicated will left most of it to his widow and daughters, though some of the local workmen from Chapin Park, including Shiells, were also mentioned. The Sullivan County property was sold off, with Rockland Light & Power Company buying over seven thousand acres on which to construct their reservoirs.

Malke Grossinger

During the summer of 1914, the Grossinger boardinghouse in Ferndale entertained nine guests and grossed a total of eighty-one dollars. Four years later, the family business had outgrown not just the original seven-room farmhouse, but also a six-room addition and the neighboring parcel purchased in 1916. In February 1919, the family purchased the much-larger Terrace Hill House from the Nichols estate—the Grossinger legend had begun.

Much of that early success was due to the hard work, and home cooking, of Malke Grossinger.

With her old-world work ethic, a passion for cleanliness and a knack for cooking hearty, tasty meals, Malke was as much the heart and soul of the growing resort as her daughter Jennie was the face. And yet it is Jennie Grossinger who everyone remembers.

Born and raised in Galicia, a part of the Austro-Hungarian Empire, Malke Grossinger came to America in 1900 with her husband, Selig, and two young daughters, Jennie and Lottie. Selig, who would eventually establish what was arguably the most famous of all Catskill resorts, had been a farmer in Europe and knew nothing of the hotel business before coming to the mountains. Malke, however, had the business in her blood.

"Malke Grumet was lovely to behold and intensely religious," Joel Pomerantz wrote in his 1970 book, *Jennie and the Story of Grossinger's*. "The daughter of a country innkeeper, she had been well trained in cooking and in the management of the inn. In every sense she was a fine catch."

When Selig Grossinger brought his family to the run-down Longbrook Farm in 1914, he had no intention of running a boardinghouse, let alone a famous hotel. He had purchased a farm and had expected to make his living from the soil. This proved to be a difficult task, and the family discussed, but was divided over, the prospect of adding to their meager income by taking in boarders. It was Jennie's husband, Harry Grossinger, who made the decision that the family should become hoteliers, and it was Malke, the one with the innkeeping experience, who made that decision a wise one.

Selig Grossinger and his son-in-law became partners in the hotel business with a handshake on a fateful spring evening in 1914.

"On that night, a partnership was formed that would last as long as either of them lived," Pomerantz wrote, "one that would make not only the two partners, but distant, as yet unborn, relatives wealthy beyond their dreams. Malke said, 'This will be good, I know. It is meant to be. We must have faith. God will help us.'"

She could not have been a more accurate prognosticator, but it took long days and a keen eye for detail to ensure that the hotel became a success. And much of both was supplied by Malke, who for nearly forty years oversaw the kitchen and the kitchen staff, working harder than any of them. In fact, it has been said that she personally sliced every piece of fruit before it was served.

This peculiar preoccupation with fruit came about as the result of an incident that took place after Malke and Selig had enjoyed a rare afternoon away from the hotel. Returning to the kitchen just as supper was being served, Malke discovered a small worm in a saucer of stewed prunes that was about to be served to a guest. Never again would she allow fruit to pass through the kitchen without her personal inspection.

Even after the hotel had become successful, and the Grossinger family wealthy and well known, Malke could be seen in the village of Liberty, dressed in her working clothes and an old scarf, purchasing kitchen utensils or food. She was seemingly unaffected by the fact that the Grossingers had become among the most famous families in America.

In fact, despite the notoriety eventually gained by daughter Jennie, and to some extent, the rest of the family, Malke remained a mystery, seen but not heard, and not seen very often at that. Little has been written about Mom, as she was popularly known, save for a brief description in Harold Jaediker

Taub's 1952 book, *Waldorf in the Catskills*, written before, but published just after, Malke's death.

"Physically one of the littlest people you've ever seen, Mom Grossinger lives her life with a courage that might well be the envy of giants," Taub wrote. He continued:

> *Her convictions are not so different from anyone else's. Many of us believe in the ideal of brotherhood. Many of us feel the obligation of the fortunate to help those who need it. But have you ever heard of another person who has given to the needy every penny of cash he possessed? That's Mom. She has no money in the bank. Every month she gets a large check, her income from the hotel, and immediately sits down and writes checks until it is all gone. Asked about it, she shrugs. "My family doesn't need my money. A roof over my head and three meals a day I'm sure of. What else do I need?"*

DANNY KAYE

It has often been said that the first play Danny Kaye ever saw, he was in.

That would have been in June 1929, at the White Roe Lake House in Livingston Manor, where the soon-to-be legendary performer got his professional start and refined his trademark comedy routine.

It's not that Kaye (David Daniel Kaminsky) had never performed before. He and his partner Lou Eisen, better known in the Catskills in later years as Lou Reed, had been singing at parties, social affairs and street corners in Brooklyn for over a year when they were discovered by Nat Lichtman, the entertainment director at the White Roe.

Lichtman was visiting his mother in Brooklyn one weekend, and stopped at a local candy store to use the telephone when he came across "Red and Blackie," as Kaminsky and Eisen had dubbed themselves, singing duets on the corner. He hired them on the spot to work for him that summer in Livingston Manor.

In his 1994 biography of Kaye, *Nobody's Fool*, Martin Gottfried spends quite some time on the White Roe years. It was there, after all, that Danny Kaye was born. It was his tenure at White Roe, undeniably, that convinced Kaye that he could succeed as an entertainer. The story of Danny Kaye, then, is in some ways the story of White Roe.

Gottfried relates how Meyer Weiner brought his family to Livingston Manor to farm and was so successful that in 1919 he purchased 750 acres

"on the face of White Roe Mountain, sloping gently down to the town lake." Weiner bought the land, not to farm, but "to create a summer place for young Jewish single people—'no families, no children, nobody under eighteen, nobody over thirty-five. Lots of athletics, all kinds of activities and all the food you can eat.'"

Weiner started out with ten rooms and added thirty tents, each sleeping four, in the second summer. Growth was steady, and by the time Lichtman brought Red and Blackie to the mountains, the White Roe was well established. "The hotel had new and elaborate facilities, with accommodations for four hundred people, albeit, five and six to a room," Gottfried related.

> *The summer of 1929 was a gala one at White Roe. A new casino had just been christened, and it was as grand as any in the Catskills. A casino was not a gambling room, but a hotel's social center, and this one was an imposing edifice, a three-story, gabled affair with brown shingles and white trim. Porches swept entirely around on two levels, offering panoramic views of the Catskills, and there was a recreation hall on the main floor. There was also a nightclub below, but it would not fully function until the repeal of Prohibition in 1933.*
>
> *Inside, on the main floor, high, arched windows and French doors were spaced along the perimeter of the recreation hall. Above the fifty-foot wide stage, the proscenium arch rose twenty feet to the ceiling, facing an auditorium whose folding chairs could seat five hundred in a pinch. The facility was as well equipped as any on Broadway, having wings and fly space, drops, dimmers, and full lighting. All of this was by the design of Nat Lichtman.*

With this backdrop, and Lichtman's guidance, Eisen became Lou Reed and Kaminsky became Danny Kaye. The two sixteen-year-old singers had been "hired as tummlers, and their job was to tummle" all day and as late into the night as necessary—in the dining room, on the front porch and down by the lake.

Gottfried noted:

> *A tummler's duties were broadly defined. Lou and Danny, besides being a harmony team in the Saturday night musical shows, were expected to participate in each night's entertainment. And there was something scheduled every night. On Sunday nights, there were concerts by the house band (drums, two violins, trumpet, three saxophones, and a piano), which at the time was Lew Sandow and his Columbia Captivators. Weeknights*

there were masquerades, campfires, or games—anything as long as it was something. Guests would even ask the owner what was scheduled between the end of dinner and the start of the entertainment.

Danny Kaye worked for seven summers at the White Roe, eventually becoming the headliner there, and then spent the summer of 1936 at the President Hotel in Swan Lake, where he made $100 a week. From there, he moved on to the classy Tamiment in the Poconos. By that time, he had already appeared in a number of movies, though nothing noteworthy.

He spent the early '40s doing stage work, including one of Moss Hart's plays, and by 1944 was a favorite of Samuel Goldwyn, who helped make him a Hollywood star. He starred for Goldwyn in *Up in Arms* in 1944 and *Wonder Man* in 1945, and then excelled in *The Kid from Brooklyn* and *The Secret Life of Walter Mitty* in 1946 and '47, respectively. Dozens of films followed, including *Hans Christian Andersen, White Christmas* and *The Court Jester*. Kaye was presented with a Special Academy Award in 1954 for his "unique talents, his service to the industry and the American people."

Halliwell's Filmgoer's Companion described him as the "ebullient American star entertainer of stage, screen, and TV," who gained "enormous popularity." In 1984, he was honored at the Kennedy Center, where President Reagan cited his tireless work for UNICEF.

Danny Kaye died of a heart attack and complications from hepatitis in 1987. He was seventy-four.

Elizabeth Worth Muller

Elizabeth Worth Muller was once among Sullivan County's most prominent women, but like so many other significant individuals of her era, she is now largely forgotten. For the most part, whether through neglect, ignorance or sheer arrogance, we today do not cherish the accomplishments of those who have come before us. Our world is worse off because of that.

Mrs. Muller was the wife of real estate magnate Rudolph Muller and the mother of Alma and Phyllis Muller. All three Muller women were active suffragists, and Mrs. Muller was once arrested for picketing the White House to obtain for women the right to vote. She was socially prominent and championed many worthy causes, sharing committee assignments with luminaries from Edna St. Vincent Millay and Sophie Treadwell to Fulton Oursler and John Sloane. She headed up the Progressive Party in Sullivan County while Teddy Roosevelt was spearheading the movement nationally

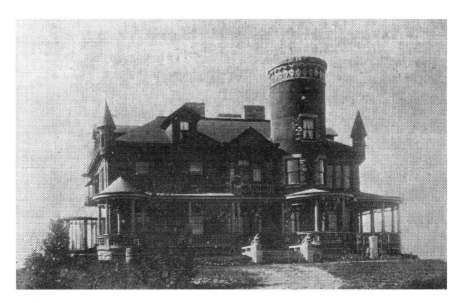

Muller Castle in Monticello.

and was the first woman in the county to procure a big game hunting license.

She and her husband maintained the uniquely styled Muller Castle on Egg Hill outside Monticello, as well as residences on Long Island and in Manhattan. The castle served as the center of activity for the family and for their causes. Upon Rudolph Muller's death in 1926, Elizabeth moved to Hollywood to be near her daughter Alma, who had married screen actor Frank Morgan. Still, during the height of her renown as a proponent of women's rights, Monticello was her home.

In 1913, the Muller women led a small party of horseback-riding crusaders on a tour of Sullivan County designed to convert local residents to the suffragists' cause.

In its August 16, 1913 edition, the *New York Times* reported:

> *Thousands of summer boarders greeted the tired suffragette hikers on their tour from Monticello to Liberty today…At Monticello, the misses Muller* [Alma and Phyllis] *were added, and they were so very much excited that they at once hired horses and accompanied the hikers to Liberty, where the six crusaders were cheered by thousands of summer visitors along the way to the hotel, where the ladies will spend the night. The meeting at Liberty, in front of the Post Office, held a crowd of over a thousand persons until a late hour tonight, and the hikers were much relieved to get back to the hotel.*

Only two farmers have been found to disapprove of suffrage, but they were quickly won over by the crusaders, and were made to promise to vote for the cause when the time comes. Many others promised to do so for a kiss, but this line of political graft did not work.

The following summer, Mrs. Muller hired an ox-drawn wagon to help with her fight for the vote.

The *Times* noted on July 3, 1914:

The oxen will draw the women and a camper's outfit from place to place. When they come to a desirable place to stop, the women will pitch their tents and do battle for their cause as long as there is an enemy in sight, and then move to conquer other fields. There will not be an "anti" in Sullivan County, the Women's Political Union workers of New York say, when they and the oxen have traveled through it.

On July 26, 1914, the *Times* made note that the ox-drawn wagon was proving to be quite the hit with the large crowds the suffragists were drawing:

Local interest is now centered on Mrs. R.J. Muller, the well-known suffragist of Monticello, and her associates, who are here for the purpose of converting the residents to woman suffrage. The party is touring the county in a "gypsy wagon" drawn by a team of black and white oxen. This novel sight attracts more attention, perhaps, than the speakers themselves.

In 1916, Elizabeth struck still another blow for women's equality when she became the first woman to legally shoot a deer in Sullivan County.

"Mrs. R.J. Muller, the local suffrage leader and chairman of the Hughes Alliance Club of Sullivan County, was the first woman in this county to take out a hunting license," the *Middletown Daily Times-Press* reported in a Monticello-datelined story on November 14 of that year. She hired as guides two local men, Vincent Masten and Herbert Vreeland, and after spending two days on the open trail, she brought down "one of the finest specimens of the deer family seen in this section for a long time. The buck deer killed by Mrs. Muller tipped the scales at 210 pounds and will be cut up and distributed among her numerous friends."

Alma and Phyllis Muller followed eagerly in their mother's footsteps, marching in parades at an early age and generally supporting the cause.

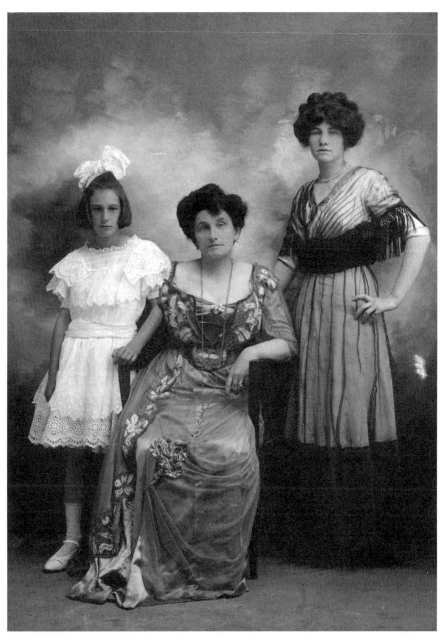

Elizabeth Worth Muller with her daughters, Phyllis and Alma. *Courtesy of the Screen Actors Guild Archives; Frank Morgan Collection.*

Alma was an accomplished athlete and horsewoman in her own right, who once rode her favorite steed from the Mullers' Hempstead, Long Island home to their Monticello estate in two days. Because of her mother's political activities, Alma had, by the time she was twelve years old, shaken hands with President William McKinley, Admiral Dewey, presidential candidate and Ulster County resident Alton B. Parker and Buffalo Bill Cody.

In 1914, at the age of nineteen, Alma secretly married Frank Wuppermann, a nephew of Mrs. E.H. Harriman, and then sailed to Europe with her father. Upon her return that fall, she informed Wuppermann, who was just beginning his stage acting career, that she had changed her mind and would rather kill herself than live with him. He immediately announced their union to the papers, and after a *New York Times* article on November 1, 1914, proclaimed "Bride Secretly Wed Longs For Freedom," the two reconciled. He would eventually move on to motion pictures and change his name to Frank Morgan.

Phyllis Muller, the younger daughter by five years, also traveled extensively and attended the best schools. She surreptitiously married New York clothing merchant Louis Reinus in Kansas City, Missouri, on September 28, 1925, but no one knew until that December. Their marriage was a rocky one, and after a number of separations, Phyllis filed for divorce in 1936, citing her husband's domineering and quarrelsome attitude. "He called me vile names," she told the court. "I left him twice, but came back, hoping he would change, but finally I had to leave permanently."

Frank Morgan was the primary witness for his sister-in-law throughout the divorce proceedings.

WILLIAM A. THOMPSON

Of all the prominent men in Sullivan County's history, only William A. Thompson has a town named for him. It is a singular honor most befitting a singular man.

The town of Thompson was formed before the county itself, in March 1803, and was one of the five towns—Liberty, Lumberland, Mamakating and Neversink were the others—carved from Ulster County when Sullivan was chartered in 1809.

It has become the most populous, and arguably the most visible, of Sullivan County's fifteen towns. It is home to the county seat, the county's largest village, the courthouse, Government Center and the county's largest employer.

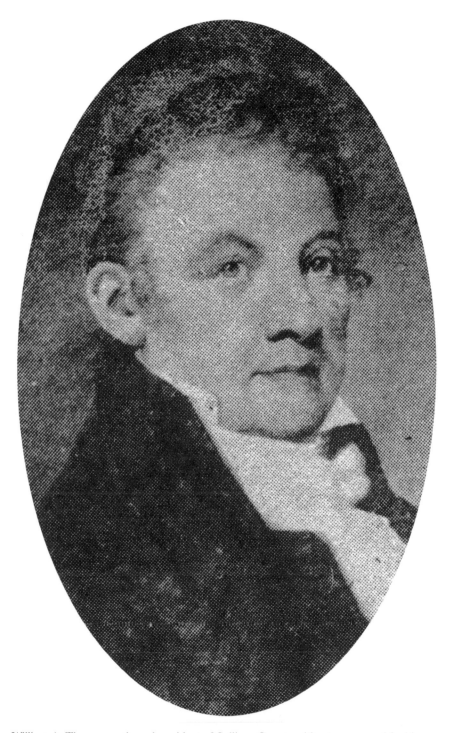

William A. Thompson, the only resident of Sullivan County with a town named for him.

William A. Thompson was born in Woodbury, Connecticut, on June 15, 1762, the oldest of the eight children of Hezekiah and Rebecka Judson Thompson, devout Presbyterians and respected members of the community. Hezekiah was a lawyer whose ancestors, according to James Eldridge Quinlan in his *History of Sullivan County*, "came from London in 1637 with Governor Eaton, and settled in New Haven."

Quinlan wrote that William was "a weak, puny child, much afflicted with salt-rheum [a chronic skin disease]." He attended public school and worked on the family farm until he was thirteen, "after which he studied with Reverend John R. Marshall, an Episcopal clergyman of the place, who undertook to prepare his pupil for college."

Thompson was a good student, who found time for studies when he wasn't fishing. He graduated college in New Haven and studied law with a number of capable attorneys, including his father, before being admitted to the bar in 1784. He married Frances "Fanny" Knapp, a "tall, genteel, 16 year old much marked with the small-pox" on July 17, 1785. She died of tuberculosis in 1788, after bearing two children.

Thompson fell in love with Amy Knapp, his wife's sister, and they married in New York City in 1791. Quinlan wrote that "in Connecticut he could not marry his deceased wife's sister without suffering a severe penalty," so he gave up his practice there and began anew on Water Street in New York.

But Thompson's health was still poor, and he began developing what in his day was termed nervous debility, which he feared would cost him his livelihood, if not his life. Making frequent trips to the country for rest and relaxation, he fell in love with the area and, in 1794, bought large tracts of land in what is today Bethel, Thompson and Neversink. He had a sawmill and gristmill constructed on the Sheldrake Creek, and in the spring of 1795, he moved his family into a small log home that he had constructed just southeast of there, becoming the first permanent settler in the town that would eventually bear his name.

This distinction alone might have qualified Thompson for the honor, but his life was far from over. While encouraging the settlement of the community he dubbed Albion, he continued to progress professionally and, in 1802, was named to the Court of Common Claims in Ulster County by Governor George Clinton. In 1803, he ascended to First Judge. Quinlan wrote that "the duties of [this] office he discharged credibly until the county of Sullivan was erected, when he became its Chief Magistrate, and remained so until 1823, when he became ineligible by reason of his age."

By the time Thompson had completed his imposing Thompsonville mansion in 1810, his wife Amy had died and he had married a third time,

to Charity Reed, daughter of Samuel and Elizabeth Guyer and widow of Shadrach Reed, who had died just after his election as Thompson town clerk in 1805.

Quinlan wrote that the mansion, which Thompson called Albion Hall, was the most magnificent home in the county at the time, "and its internal arrangements, with its corniced rooms, ornamental mouldings, and carved panels, were the local marvels of that day." The judge loved to entertain, and he

> *induced many of his metropolitan friends to spend weeks and months with him, when it was his delight to crown his generous board with haunches of venison, flanked with such trout as we do not often see in modern days, as well as wine of choice brands and ancient vintage. Tradition says that on one occasion he caused a buck to be roasted whole, and that his visitors as well as his rural friends had a grand feast. These things, of course, excited envy, hatred, and malice among some and caused ill-natured remarks. Thompsonville was long known as "the city," a sobriquet bestowed on the place because Albion Hall generally had in it visitors from the city of New York.*

When Thompson traveled abroad, he was treated royally by dignitaries in England and France, although Quinlan said some of his detractors claimed this was only because he had been mistaken for his cousin, Smith Thompson, a justice on the U.S. Supreme Court and unsuccessful candidate for governor of New York in 1828.

After retiring from the bench, Judge Thompson wrote a number of well-received articles on geology for noted publications and established a reputation as a knowledgeable scientist. When President Andrew Jackson died in 1845, Thompson was selected as a pallbearer for the funeral procession in New York City.

Judge Thompson died peacefully at Albion Hall on December 9, 1847. His home, which he often said would remain in his family forever, still stands formidably, as does the town that bears his name.

PART II

SCANDALS AND DISASTERS

INTERNATIONAL MAN OF MYSTERY

There is not a more intriguing figure in Sullivan County history than Philip L.E. Del Fungo Giera.

This mystery man, who for many years owned thousands of acres just outside Mongaup Valley, may or may not have been an international spy, an inventor, a munitions salesman, an arms dealer and a swindler. In fact, he may or may not have been Philip L.E. Del Fungo Giera.

Despite two different trials and a highly publicized U.S. Senate hearing in which he inadvertently took center stage, there wasn't much about Giera that anyone knew for certain. The U.S. government maintained for years that he was really Peter Brenner Jr., the son of a Sullivan County auto mechanic with a history of mental illness. Giera steadfastly refuted that charge, swearing under oath time and again that his real father had been a member of the Swiss cabinet with whom his mother had carried on an illicit romance while living in Zurich. His mother, he said, had later married the mechanic Peter Brenner Sr. and had four other children.

The circumstances surrounding his birth are just some of the many inconsistencies in Giera's—or Brenner Jr.'s—fascinating and exotic life.

Giera first came to the public's attention in 1928, when he was taken to court by a New Rochelle real estate firm that claimed the payment for a Pelham Manor home he had purchased from it had included $30,000 in worthless stock in Sullivan County property. During the trial, attorneys for J. Louis Bloom & Sons, Inc. attempted to prove that Giera was really Brenner, who had previously been convicted of embezzlement in Europe, and that he

had long ago stolen the identity of the real Philip L.E. Del Fungo Giera, an Italian diplomat.

"The charge was denied from the witness stand," the *New York Times* reported on January 12, 1928. The *Times* said Giera told the judge "he was the son of Phillip Edward Brustlein, a member of the Swiss Cabinet, and Minna Auer, who, after his birth, was married to Peter Brenner, who is now living in Sullivan County." Giera's attorneys actually produced his aged mother to testify to that claim, a contention contradicted by the attorneys for the plaintiff, who put on the stand Brenner Sr., who positively identified Giera as "my dear son, Peter."

Giera invoked immunity from answering questions because of the secret work he was performing for the government and, to back up his claim, produced papers showing he was a federal deputy game warden, as well as letters from the Secret Service and the Conservation Department.

"The witness then said that he had received a commission as a Captain in the Swiss intelligence service before he left Switzerland in 1902, and that he gave all of his credentials on his arrival here to his 'chief,' whose identity he refused to reveal," the *Times* noted.

Giera further claimed that he had spied for both the United States and Germany as far back as 1915, and had since done work for the U.S. Army and Navy. All of this contradictory testimony caused the judge in the case to reserve any decision.

For a few years thereafter, Giera kept a low profile, but his activities came to light as part of the Senate's investigations into the munitions industry as the Nazis gained control in Germany and began to rearm, in violation of existing treaties.

"[Giera] was too busy working out his own schemes up in his laboratory in Sullivan County," the *Washington Post* reported in September 1934.

In 1932, he approached the Remington Arms Company with a new invention that he claimed would revolutionize the making of ordnance throughout the world. They were interested.

He told them that he had devised a method by which hydrogen could be used in place of powder as an explosive. They lent him a three-inch navy gun that they had in their exhibition room to test this marvelous contraption. It seems that it was a bit of a failure.

It came out in the munitions hearing last week that he had approached the du Ponts in February of last year, exhibited a friendly letter from Germany's vice chancellor Von Papen, and interested them in the idea of making him their sole agent in Germany and Holland.

Scandals and Disasters

The du Ponts signed Giera to a contract in 1933. When the Senate began investigating the illegal sale of armaments to the Germans, Giera, by then living along the Mongaup, was again thrust into the spotlight. The du Pont brothers told senators that they had thought better of their arrangement with Giera and had torn up his contract the day after it had been signed. Anything he had done subsequent to that, he had done on his own, they said. Curious Senate investigators looked into the background of this mysterious salesman and stumbled upon the earlier allegations that he was really the con artist Brenner.

Washington Post reporter Osgood Nichols traveled to Sullivan County to interview Giera and found his compound nearly inaccessible.

"One drives for two miles along a tree-lined private road from the gate house to the Giera mansion," Nichols wrote. "Three large dogs straining at their leashes make the entrance a bit forbidding."

Neither the Senate hearings nor the *Post*'s investigation did much to clear up the mystery of Giera's past. "It seems to be a toss up whether or not Giera is Giera or Brenner, or perhaps even someone else," the paper reported. "At any rate, he was a captain in the Swiss Intelligence Service and was assigned to Germany in accordance with the usual practice of sending 20 Swiss officers every year to serve with the German army for training. That seems to have been the real beginning of his long career."

Despite all the allegations of fraud, Giera was not prosecuted. Whether it was for lack of evidence or because he really was working for the government was never established. But his troubles were far from over.

In 1941, Giera was in the national news again, this time charged with fraud in connection with $12,000 he had obtained by convincing people he "had connections."

"A legendary figure from Mongaup Valley came reluctantly to town yesterday in the person of a ruddy-cheeked, bristly haired, rotund man named Philip L.E. Del Fungo Giera, according to his own statement, and Peter Brenner, according to the Federal authorities," the *New York Times* reported in a September article under the headline, "Mystery Man pays Visit to the City." Giera—or Brenner—had been "picked up at his 2,000 acre Sullivan County estate by deputy United States Marshals, to answer charges of impersonating government officials."

Although Giera surrendered without incident, the marshals who came to arrest him were treated to a taste of the security he employed. Talking to some of Giera's neighbors had made the marshals wary of approaching his mansion, and they proceeded with caution.

The *Times* article described the scene:

> *Before they could see his house, they reported, they had to go through a barn. From this they emerged on a picturesque lawn, which they had been told was guarded by electric eyes. At one point they got the impression that one of the eyes had spotted them, and bells pealed in the distance. As they approached the house, they saw six German shepherd dogs chained up. But they had been told that Giera could release the dogs by a device inside the house. Be that as it may, they said, they got to the house and were able to arrest Giera without any resistance on his part.*

The government branded Giera as a "sinister international figure" and charged in federal court that he had obtained $10,000 in 1939 and $2,000 another time "just by convincing people that he was a very ingenious inventor with government connections."

According to the *Times*, Giera testified that he was developing in his Mongaup Valley laboratory "a gas to paralyze people, an antidote for the gas, and an explosive that has the peculiar property of exerting all of its force downward." He also claimed to have invented a substance "which, when placed in an envelope, would suddenly burst into flame," and something that when spread onto sand "would take fire when trod upon by a barefoot person, especially an Ethiopian."

The government charged that Giera had on his estate a thirty-seven-millimeter field gun and a three-inch naval gun. They said he "had voluntarily declared that he had served as a spy for 21 countries, including the United States," and that once "while getting $2,000 from somebody, the inventor claimed that he was in continuous short-wave radio contact with Germany and always knew what was going on there."

Government witnesses testified that some of Giera's "inventions" were actually centuries old, while others were nothing more than vaudeville tricks. Federal judge Charles G. Briggle found Giera guilty on four counts of impersonating public officials, but rejected five other charges on technical grounds. Giera was sentenced to eighteen months in federal prison and fined $1,000. Briggle noted that government prosecutor Raymond Ickes had failed to show "that the defendant was quite the 'vicious character' that Mr. Ickes considered him."

The sixty-seven-year-old Giera faded from view after serving his sentence, and there is little left today to remind folks that he once lived so lavishly. In fact, much of his once magnificent estate on the Mongaup River has long since been flooded by the Swinging Bridge Reservoir, only adding to the mystery of Philip L.E. Del Fungo Giera.

THE WORST WOMAN ON EARTH

There is no more despicable person in Sullivan County's history than Lizzie Brown Halliday. She was known to have murdered at least five persons and was suspected of killing many more. When she died in 1918—in the Matteawan Hospital for the Criminally Insane—she was described as "the worst woman on earth."

And much of the country believed, at least for a time, that she was the notorious London murderer known as Jack the Ripper.

She was born Eliza Margaret McNally in County Antrim, Ireland, in 1864 and came to this country with her parents three years later. She married Charles Hopkins, also known as "Ketspool" Brown, in 1879 and gave birth to a son. Hopkins died two years later, and shortly thereafter, she married Artemus Brewer, described by the *New York Times* as "a veteran and a pensioner." He died after less than a year of marriage.

"Whether these men died natural deaths or were murdered, is not known," the *Times* noted on June 19, 1894, as her murder trial got underway in Sullivan County Oyer and Terminer Court.

The *Times* continued: "Her next venture was Hiram Parkinson, who deserted her within a year. She then married, Parkinson being still alive, George Smith, a veteran and a comrade of her second husband, Brewer. In a few months she tried to kill Smith by giving him a cup of poisoned tea. Failing in her design, she fled to Bellows Falls, VT, taking with her every portable article in the house."

While in Vermont, Lizzie married Charles Playstel and lived with him for about two weeks before disappearing. She turned up in Philadelphia some time after and arranged to stay with the McQuillan family, who had been the McNallys' neighbors in Ireland. She opened a small shop there and shortly thereafter burned it for the insurance money. Arrested for that crime, she served two years in prison.

After her release from the Eastern State Penitentiary in Philadelphia, she turned up in Newburgh, where she met Paul Halliday, a widower living in Burlingham with his sons. She went to work for him as a housekeeper, and he eventually married her—though neighbors later said the marriage was just his way of avoiding having to pay her.

"Their married life does not seem to have been pleasant," the *Times* reported, in what must rank as one of the greatest journalistic understatements of all time. "She soon eloped with a neighbor, stealing a team of horses in order to accelerate their flight. In Newburgh, her companion deserted her, and she was arrested. Her counsel entered a plea of insanity, and she was sent to an asylum."

Lizzie convinced her husband to gain her release from the asylum, and she returned the favor by burning down his house, a barn and a nearby mill, killing one of his sons in the process. Then Paul Halliday disappeared. Lizzie told the neighbors that he was traveling, but they searched the property, suspicious of her claim. They did not find Halliday, but they did turn up two bodies under a haystack in a barn. They turned out to be Margaret and Sarah McQuillan, the wife and daughter of the man who had provided Lizzie a home in Philadelphia. They had both been shot.

A few days after arresting Lizzie for the murders of the McQuillans, authorities discovered the body of Paul Halliday under the floorboards of his house. Lizzie was charged with that crime, as well, and confined to Sullivan County jail to await trial. Her time there was not uneventful.

The *Times* reported:

> *For a long time after her arrival, she refused to eat, and it became necessary for the jail physician to force liquid food through her nostrils. In November, she tried to strangle the Sheriff's wife. A few days later, she set fire to her bedclothes. In December she tried to hang herself with the binding torn from the bottom of her dress. On December 15, she came near ending her life by gashing her throat and arms in a terrible manner with glass broken from her cell window. For the last three months it has been necessary to keep her chained to the floor.*

During her time in the county jail, Lizzie became a national celebrity. The New York City newspapers, ever on the lookout for a sensational story, soon discovered the Halliday saga and gave it front-page coverage. Papers from around the country followed suit.

"From its circumstances, origin, conception and execution; its unique characteristics, the abnormal personalities and peculiar localities it involves, and, above all, in the strangeness and mystery of its great central figure, it is unprecedented and almost without parallel in the annals of crime," *New York World* reporter Edwin Atwell wrote of the case.

The *World*'s coverage didn't stop there. Enterprising columnist Nellie Bly also capitalized on the sensational aspects of Lizzie's life and made two trips to Monticello to interview her, following up each time with protracted articles.

It was while she was being held in Monticello that Lizzie was linked to the London murders. Sheriff Harrison Beecher issued a statement to the press indicating that "recent investigations show that Mrs. Halliday is in all probability connected with the famous Whitechapel murders."

The grisly details of Jack the Ripper's five 1888 murders were still fresh in the public's mind in December 1893, when Beecher made his announcement

that "it has been proved that she was in Europe at the time. She frequently refers to the subject, both when she is in possession of her mental faculties and when she is raving."

The *New York Herald* reported Beecher's assertions, and the dispatch was picked up by newspapers from Frederick, Maryland, to Marion, Ohio. "We suspect that this mysterious creature was connected with the horrible Whitechapel murders," the *Middletown Daily Times* reported on December 4, 1893, noting that Sheriff Beecher asked the suspect point blank about her involvement. The sheriff additionally said, "I said to Mrs. Halliday, 'Lizzie, you are accused of the Whitechapel murders. Are you guilty?' 'Do you think I am an elephant?' she replied. 'That was done by a man.'"

"Mrs. Halliday is constantly speaking of these murders. She also talks of many women brought from New York who have been robbed, killed, cut up in small pieces, and dumped in the Hudson River."

That Lizzie Halliday denied involvement in the Ripper murders was not surprising. At times, she proclaimed her innocence of all the crimes in which she was suspected, often claiming that she had been drugged by a band of brutal gypsies and forced to watch while they committed the crimes. Still, the possibility that she was the reviled Ripper was realistic enough that she is listed in Christopher J. Morley's 2005 book, *Jack the Ripper: A Suspect Guide*, though Morley ultimately concludes that "while Halliday was clearly insane and had mutilated two of her victims, and judging from the newspaper picture of her was quite masculine in appearance, there is no evidence to connect her to the Whitechapel murders."

Convicted of the Sarah McQuillan murder, Lizzie Halliday was sentenced to be executed, but her sentence was commuted. She spent the rest of her life in the Matteawan Hospital for the Criminally Insane, where she was a constant source of trouble, attempting to escape a number of times and assaulting several attendants, including nurse Nellie Wickes, who was stabbed more than two hundred times in 1906, after she told Lizzie of her plans to leave the hospital for other employment. Nurse Wickes died from her wounds.

Lizzie Halliday died at Matteawan on June 18, 1918.

THE HIDDEN WOMAN

Few stories have so captured the imagination of the people of Sullivan County as the tale of the "hidden woman of Monticello." And that's as true today as it was when the story first came to light in December 1913.

That's when the quiet of a Monticello night was broken by a scantily clad woman racing through the streets from the Masonic Building on Bank Street to the home of Dr. J.R. Curlette on Broadway to summon the doctor to the law office of Melvin H. Couch, who had collapsed just moments before. Curlette, awakened from a sound sleep, followed the ghostly woman back to the Masonic Building to find Couch, his brother-in-law, dead on his office floor. As events unfolded, it became known that the woman, Adelaide Branch, had been Couch's lover, and that he had created a secret room within his office space in which she had lived for three years. Couch's wife, who had never suspected the arrangement, later said that Couch had been sleeping at the office during the week, coming home to their tidy brick house on the corner of Spring Street and Broadway only on Sunday afternoons. It turned out to be quite a scandal and even made its way onto the front page of the *New York Times*.

But neither the story nor the newspaper's interest in it stopped there.

The *Times* assigned a "special correspondent" to follow the investigation into the incident and to delve further into the life of the mysterious woman who had captured the imagination of readers everywhere. The *Times* reported that the woman's name was Brance, not Branch, as had been reported repeatedly in the local papers. (Although her name appears as Brance throughout the *Times*'s coverage, and in many other papers, as well, other papers stuck with Branch, which appears to be correct.)

The *Times* tracked down the woman's brother, Herbert O. Branch (or Brance), the postmaster at Hartwick, in upstate New York. When interviewed on Christmas Eve 1913, just a few days after the incident, he was less than sympathetic, dwelling on how his sister's actions had affected the family.

"I will go to my sister on Christmas Day and help her to make plans for the future," he told the *Times* while his sister was still being held under guard in Monticello. "I will not harbor her at my house nor will I bring her back to Hartwick with me. I am sorry for what she has done, but I cannot allow her to live at my home. I am afraid that none of her relatives who live in the vicinity will shelter her. I do not know what she intends to do. My wife does not know anything about it yet, and I am trying to keep it from her as long as possible."

Perhaps no one was so affected by the incident as Couch's old friend Stanley Smith of Monticello. Shocked by the discovery of his former schoolmate's indiscretion and the sparse turnout at his funeral, Smith took his own life with a revolver given him some years before by Couch himself.

Scandals and Disasters

The *Times* reported on Christmas Eve:

> *With an old-fashioned revolver, which Melvin H. Couch had given him, Stanley Smith killed himself this evening. He had been deeply grieved by the revelation of Couch's secret life which was made to Monticello and to all the world when Couch died suddenly Sunday morning. No one in the village was more shocked than Mr. Smith. He was a retired jeweler, who, like Couch, was 65 years old, and who had been to school with the man who afterward became one of the leading lawyers in this part of the state. And he was saddened by the slimness of the group that went to the funeral and by the shortness of the file of carriages that followed the hearse out to the snow-covered cemetery.*
>
> *At sundown this evening, he asked his wife to do his chore—feeding the chickens—and while she was scattering the corn in the yard at the rear of their home on Liberty Street he went to his room and got out the old revolver. It was of a by-gone make with an extremely long barrel, and to turn it against himself he had to place the muzzle at his temple, steady the handle against the wall, and work the trigger with a stick. His wife found him dead on the floor.*

It turned out the "revolver" was not just any gun, but one with an interesting history all its own. Despite the *Times*'s contention, it was probably not a revolver at all, but rather a shotgun, said to be a souvenir of the biggest case Melvin H. Couch had prosecuted while serving as Sullivan County District Attorney, the murder trial of Abel "Sailor Jack" Allen in 1888. Allen was convicted of killing a Jeffersonville boardinghouse owner and became the last man hanged in Sullivan County.

"Couch, then in his prime, was the prosecutor," the *Times* noted, "and when, with a nonchalance that is still a favorite story in Monticello, Allen paid the death penalty, Couch asked the Sheriff for the gun Allen had used in the murder. It was this gun which later Couch gave to Smith, and with which Smith this evening took his own life."

Adelaide Branch remained in the hospital section of the Monticello jail until December 28, when she slipped away in the dead of night.

The *Times* reported on December 29:

> *Monticello is unaffectedly glad to have her gone. As the shock of last Sunday's tragedy has worn away, the villagers—not just a few of them—have been moved to vigorous denunciation of the "hidden woman." As the week drew to a close, some of the taxpayers began to realize that this woman, against whom no charge stood, was being lodged at their expense*

at the county jail. With the Sabbath leisure at their disposal, some of the leading citizens said today that had not Miss Brance slipped away when she did, they would have felt obliged to ask for an investigation into the method of meeting the expenses of her visit in the jail. She left after assuring the Sheriff that she would go to the almshouse before she would accept any of the various tempting theatrical offers made to her.

With the help of bestselling author Upton Sinclair, who had heard of her plight and taken an interest, Miss Branch underwent psychiatric therapy in New York City and embarked on a writing career. Within a few months, she had disappeared from view, and the public's attention—and the *Times*'s—had moved on to fresher scandals.

The Great Liberty Fire

Friday, June 13, 1913, was an especially unlucky day in the village of Liberty, as nearly half of the village's business section was wiped out in one of the most destructive fires in the history of Sullivan County.

It was sometime after four o'clock in the afternoon when the fire alarm sounded, and by the time firemen responded, a number of buildings were already in flames. When it was all over some three hours later, the village was in ruins, with estimates of the damage reaching as high as $500,000.

The Liberty fire ranks as the second most devastating fire in the county's history in terms of property loss, topped only by the epic 1909 fire in the village of Monticello, which resulted in property losses exceeding $1 million.

Although it was never officially established how the Liberty blaze started, it is generally believed to have ignited in the barn behind the Roosa & Lancashire grocery store. It is known that shortly before the fire was detected, a man named Thomas Washington had made a delivery of hay to the barn, which served as a storehouse for the grocery, but it is not known if that was in any way connected to the start of the fire.

In a rare special edition "Extra," the *Liberty Register* reported the next day that "with such incredible speed did the flames spread that they had gained uncontrollable headway before the firemen had hooked their hose to the hydrants. The place in which the fire started was thickly surrounded by frame buildings, that were easy prey to the flames. The firemen were hardly aware that the fire had started before the flames had raced over the entire block."

Claimed by the conflagration that afternoon was the imposing Liberty Music Hall, B.F. Green's Department Store, the Baptist Church, Jafnel's

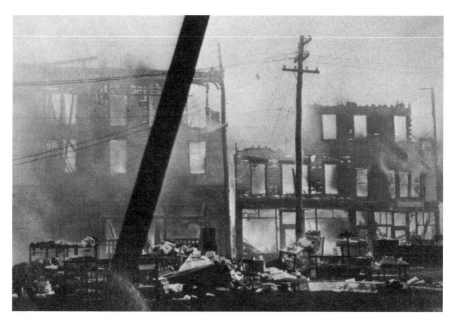

The 1913 Liberty fire destroys a block of the village's business district.

Pharmacy, Kniffen's stationery store, B.E. Misner's confectionery store, James Mance's pharmacy, William Fahrenholz's stationery store, Hasbrouck's apartment house, Roosa & Lancashire's grocery, its barn and Sherwood's livery stable. Most of those establishments lost their entire contents, as well. Other structures suffered varying degrees of damage in the blaze, and for a time, the entire village appeared threatened.

Manville B. Wakefield, writing in his 1970 book, *To The Mountains by Rail*, quoted longtime Liberty resident Dewey Borden's vivid recollections of the excitement that day: "'The fire whistle was just starting to blow,' recalled Dewey Borden, 'when I looked up the narrow alley between the Roosa building and the Hasbrouck building to see flames roaring out of the Sherwood stables at the far end.'"

Liberty firemen soon concluded that they were overmatched by the fire. According to Wakefield, "as the flames tore through the 112-foot long Roosa & Lancashire grocery and fruit store, emergency calls went out to surrounding communities, and soon Livingston Manor Hose Co., arriving on a special O and W train, was on the scene, quickly followed by Mountain Hose Co. of Monticello, Jeffersonville Hose Co., and the Lake Huntington Hose Co."

In addition, more than two hundred firemen from Middletown were on their way to the scene by train, but were stopped in Summitville when Liberty officials realized they would likely arrive too late to help.

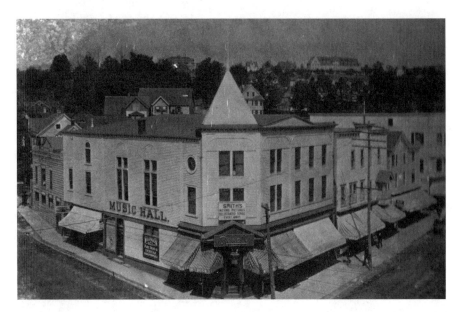

The Liberty Music Hall.

Wakefield continued:

> *When it was apparent that things were out of control, willing hands set to moving merchandise out of Green's Clothing Store, located in the Music Hall building. "You never saw a bunch of guys move so fast," recalls Borden, "as they carried out showcases, racks of clothes and assorted merchandise and piled it up on the lawn across the street in front of the Baptist Church." After sweeping the Hasbrouck block housing the James B. Mance pharmacy and the William Fahrenholz stationery and news store, the advance of the flames up Main Street was finally halted by the concrete-block Hasbrouck's Liquor Store.*

The Baptist church was almost saved through the heroic efforts of its pastor, Reverend Ralph Thorne. When the towering church steeple caught a spark and burst into flames, low water pressure prevented the firemen from reaching it with their hoses. Reverend Thorne organized a bucket brigade, which had nearly extinguished the fire when the roof caught—soon the entire building was consumed.

In the aftermath of the fire, word spread that at least one life had been lost, but that rumor proved unfounded. There were injuries, and the human toll would no doubt have been considerably steeper if not for the valiant

efforts of the firemen, who risked their lives time and again to rescue those trapped on the upper floors of buildings.

While the *Register* reported that estimates "from men well qualified to judge" put the property loss at somewhere between $250,000 and $500,000, merchants indicated that their combined insurance policies would cover no more than about $75,000. Nonetheless, all pledged to rebuild quickly, and most did.

An eerie postscript to the great Liberty fire of 1913 is all but forgotten today. Just three days later, a devastating fire claimed most of neighboring Ferndale's commercial district, destroying Kantor's Pharmacy, Hirsch's grocery, Katzmer's candy store, Steigert's bottling works and other businesses. No link between the two fires was ever established.

MONTICELLO FIRE OF 1844

January 13, 1844, was a cold day in Sullivan County. The thick layer of snow blanketing the ground had frozen so thoroughly that its crust easily supported the weight of a man, and the wind blew so fiercely that anyone braving the outdoors was literally carried along with it.

At about three o'clock that afternoon, Giles M. Benedict, a respected farmer and merchant in the village of Monticello who also served for a time as county coroner, was lighting a fire in the kitchen of his home on the north side of Main Street. Benedict's kitchen was located in a small addition at the rear, and its roof was considerably lower than the eaves of the main portion of the house. A pipe, serving as the chimney for the kitchen stove, protruded through the kitchen roof.

As the kindling in the stove caught fire, a strong gust of wind sucked the sputtering flames up through the pipe and slapped them against the neighboring cornice. The Benedict residence was ablaze within a matter of minutes. Aided by the swirling winds, the fire quickly engulfed the entire building, burning it to the ground.

The village of Monticello would not organize a formal fire department for another thirty years, but an alarm was sounded nonetheless. As recounted in James Eldridge Quinlan's *History of Sullivan County*, Benedict's neighbors responded immediately:

> *A few persons, seeing that Benedict's house could not be saved, ran to the court house to protect it, if possible. Little danger was apprehended to the house itself unless a small barn close to it caught fire. Hence the combustible*

material in and around the barn was at once drenched with water. Two men were also sent up the belfry to watch the roof. They began to congratulate themselves that the public buildings were safe, when it was discovered that the courthouse was on fire in an unexpected quarter. It was burning on the west side, between the dry pine siding and the equally dry ceiling, where it was impossible to get at in time to check it. At once there was a roaring column of flame from the foundation to the roof. So rapid was the progress of the fire, that one of the persons (an old negro) in the belfry, escaped with difficulty.

The courthouse was soon destroyed, and though the neighboring county clerk's office was brick, it had a wooden roof and soon was on fire, as well. The Presbyterian church also quickly succumbed to the flames.

Quinlan further recounted the scene:

A fiery blast seemed to sweep over these buildings, obliterating all that was combustible from the face of the earth. The lower part of the village from the Mansion House seemed doomed. The air was full of burning coals, and cinders, while blazing shingles and fragments of siding were driven by the gale rapidly over the smooth crust of the snow for at least a mile. Piles of household goods, which had been removed from exposed buildings, barns, etc., were momentarily catching fire, while the citizens were exhausted by their efforts.

When the fire finally burned itself out, a dozen buildings, including the courthouse, clerk's office and Presbyterian church, had been damaged or destroyed, causing an estimated $16,000 loss. But, as Quinlan noted, the aftermath of the blaze was even more far-reaching and historic:

Before the ashes of the county buildings were cold, it was apparent that there would be a formidable attempt to change the site of the courthouse and the clerk's office. In some of the towns, there was an obstinate prejudice against Monticello and its prominent inhabitants. This prejudice originated on social, business, and political grounds, and at that epoch of our history was natural.

It was charged that, while the people of Monticello were in no respect better than their neighbors, they assumed social superiority, and that, with the exception of a few families of other towns, who were as exclusive as themselves, they did not associate with those who were outside the narrow circle of the village.

Application was made to the Legislature of the State for a law to remove the site of the county buildings to Halfway Brook or Barryville, where the people pledged ten acres of land and three thousand dollars toward the cost of the necessary edifices; to the lands of John Holley, in West Settlement, who promised a site and one thousand dollars; to the Neversink Falls in the town of Fallsburgh, where the people pledged nothing, but asked for the annexation of the town of Wawarsing to Sullivan, probably to make the Falls nearer the center of the county; to the village of Liberty, where the applicants pledged that they would erect the courthouse and jail free of expense to the county; to Wurtsborough and to Forestburgh, on the same conditions.

After much debate and deliberation, the state legislature finally ordered that the county buildings be rebuilt in Monticello, but the decree did little to heal the rift the issue had created on the Sullivan County Board of Supervisors.

The Worst Fire in Sullivan County History

Peter C. Murray was a bright, energetic and innovative entrepreneur who erected one of Monticello's showpiece buildings and helped usher the village into the twentieth century, but for some he will forever be remembered—however unfairly—as the man responsible for the worst fire in Sullivan County history.

About 1890, Murray had purchased the old Commercial Hotel on the corner of Main and Orchard Streets in Monticello (known as Broadway and Landfield Avenue today) from longtime town clerk Al Gillespie, and promptly replaced the venerable but undersized building with a magnificent yellow brick, four-story, turret-topped structure he called the Palatine Hotel. He followed that by erecting the equally impressive Palatine Theatre and Hall, which connected to the rear of the hotel. Then he built an electric power plant adjoining the theatre to provide the lighting for his two businesses. This new-fangled concept proved so popular with village residents that other businessmen were soon prevailing upon Murray to produce power for them, as well.

In response to this growing demand, Murray began construction of a new, enlarged power plant in 1904. This plant would provide enough electricity to supply the entire village, and its exhaust fumes would be used to heat the hotel and the theatre throughout the winter. Before long, virtually all of Main Street was electrified, and state-of-the-art electric streetlights illuminated

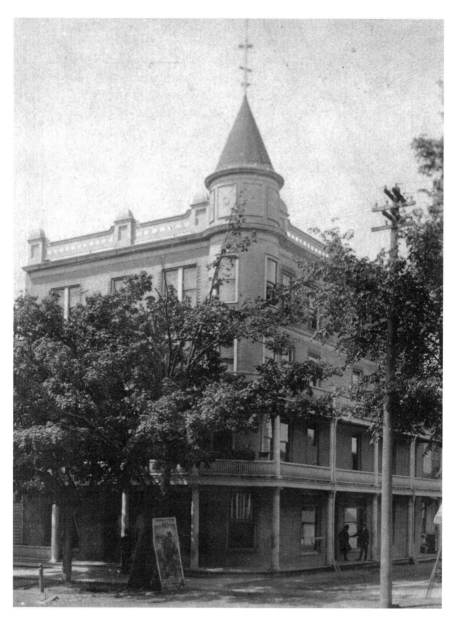

The Palatine Hotel.

most of the business district. The village of Monticello was much the better for Murray's investment.

But something went terribly wrong at the power plant on the evening of August 10, 1909. An errant spark ignited something within the building and it caught fire sometime after eight o'clock. Fanned by a stiff summer breeze blowing from the northwest, the fire raged out of control, and the powerhouse was totally involved by the time the alarm was sounded at about 8:30 p.m. As the *Republican Watchman* newspaper later reported, "The flames spread and in an hour the entire village seemed to be doomed."

The theatre caught fire almost immediately and, in the words of the *Watchman*, "in less time than it takes to chronicle it, that place of masquerade, frolic and fun was in a mass of flames." Despite the vigorous efforts of the village's three fire companies, there was little that could be done to save the hotel building, which caught fire next. One of Monticello's most beautiful structures was quickly consumed, and the destruction was just beginning. As Manville B. Wakefield wrote in *To the Mountains by Rail*, the hotel building "became a fire-brand that put the torch to the village."

The fire raced both up and down Main Street and then jumped the wide expanse of thoroughfare, igniting buildings on the other side. It raged all through the night and well into the next morning. By the time it was finally extinguished, Main Street was in ruins. In all, seventy-four businesses had been wiped out, and the property loss was estimated at over $1 million dollars. (That's nearly $20 million in today's economy.) The beautiful and distinctive shade trees that had lined the village's principal street were destroyed, too, and would never be replaced.

The north side of Main Street from the Carlton Hotel to the National Union Bank was burned to the ground. Buildings destroyed on the opposite side of the street included the heralded Hotel Rockwell on the southwest corner of Main and Mill Streets. The large three-story structure, with its many porches and imposing corner tower, was operated by former county clerk George W. Rockwell and was one of the village's most well-known businesses. Rockwell had purchased what had been the Hahn Hotel some years before and had greatly improved and expanded it, until it was regarded far and wide as among the finest establishments of its kind in the area. The ornate wood structure succumbed quickly to the flames, leaving just a chimney and a decorative iron fence standing. The hotel was never rebuilt.

For the most part, business owners were quick to respond to the devastation, as were village officials. Joseph Engelmann, who served as the president of the village council—the equivalent of today's mayor—ordered a village employee to New York City the very next day to purchase seventy-two new

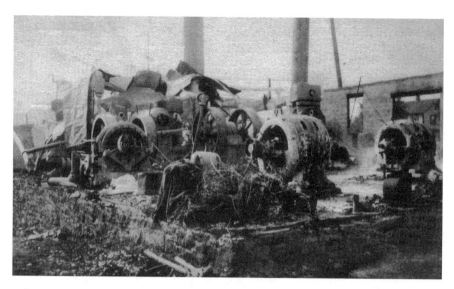

The power plant behind the Palatine, where the 1909 Monticello fire started.

electric streetlamps. Temporary shacks were erected to house the displaced businesses, and all available manpower was devoted to cleaning up the rubble. Still, by the summer of 1910, the rebuilding effort had not been completed. The O&W (Ontario and Western) Railway reported in its guidebook that year that "the burnt section is being rebuilt with the utmost speed, and the town is to be congratulated on its splendid effort toward rehabilitation."

By 1912, downtown Monticello had been entirely rebuilt and a new power plant had been constructed on St. John Street, away from the center of town. The village had undergone a major facelift, and more changes were on the way. On June 30, 1919, another great fire destroyed another section of Main Street. That blaze started in the Arcade Theatre and eventually claimed five large storefronts, four residences, a blacksmith shop and two hotels, the Palm and the Monticello House. Ironically, the progress of that $200,000 fire was stopped by the brick building erected by Bruce and Fred Carlisle after the 1909 fire had destroyed their grocery store.

PART III

EARLY INDUSTRIES

DINERS

Before fast-food restaurants began popping up virtually everywhere in the 1950s, diners were the place to go for a quick bite to eat or a hot cup of coffee. Although many diners offered home cooking and complete hot dinners for those who desired it, from the outset diner food was usually both quick and cheap.

In fact, a survey by diner manufacturer and business consultant Jerry O'Mahoney in the 1920s found that the average diner customer occupied his stool for just eight minutes and spent twenty-eight cents. By 1937, more than a million people a day ate or drank something at a diner. By 1948, the average check was fifty cents.

Diners are a distinctly American institution, and they have a relatively short history. In fact, it is believed that the word "diner" did not enter the vocabulary until sometime in the early 1920s. Prior to that, the predecessor to these manufactured eating establishments was a horse-drawn contraption with a counter and stools inside, which was known simply as a "lunch wagon." Regardless of the terminology used to describe them, many of these enterprises—which have always been largely concentrated in New England and the Middle Atlantic states—have achieved legendary status. Here in Sullivan County, at least a few of these places have cherished histories.

When questioned for diner memories, old-timers will inevitably recall places such as the Triangle Diner in Liberty, founded in 1938; Miss Monticello and Gager's in Monticello, which date back even earlier; and the Robin Hood Diner in Livingston Manor. Most of these, at least at one

time during their operation, met the criteria usually cited as qualification for a true diner—they had the grill right in front of the counter and they had a short-order cook who worked with true artistry, using both hands at once—but none was ever actually a lunch wagon.

Very little is known about the early lunch wagons that may have operated in the county. Mike Engle, a diner historian who specializes in Upstate New York diners, has accumulated a considerable amount of information that includes a few tidbits about these early horse-drawn eateries.

"According to city directories, Harold Gager [who later opened Gager's Diner on Broadway in Monticello] had a lunch wagon in Ellenville as early as 1912," he said, "and Daniel Sherwood had a lunch wagon in Liberty as far back as 1916."

Possibly the earliest lunch wagon in Sullivan County belonged to Phil Scheuren; certainly it was the most traveled. Scheuren, a former professional baseball player from Ashland, Pennsylvania, had served as a police officer in Deposit before moving here. He first brought his lunch wagon to Monticello in 1911, as construction of new buildings along Main Street was underway following the great fire of 1909. He had been operating in Liberty even earlier, possibly as far back as 1906. In the county seat, he first set the wagon up on the south side of what was then Main Street, on the site later occupied by Sullivan County Gas Company.

Scheuren's original cream-colored lunch wagon had a counter and nine stools, and windows decorated with pictures of George Washington and Abraham Lincoln. Scheuren moved the wagon progressively eastward along Main Street as buildings were erected, finally settling at the corner of Main and Mill (present-day Broadway and St. John Street) at the spot later occupied by the D'Ari Drug Store and then Monticello Pharmacy.

Scheuren purchased a new, larger lunch wagon in 1914 and eventually moved to St. John Street, where the Monticello Steam Laundry was later located. In 1920, the wagon was moved to the north side of Broadway, and then in 1921 to Landfield Avenue, where it became part of a permanent structure. Once there, he expanded his menu, which always featured roast beef on Monday, roast pork on Tuesday, Virginia baked ham on Wednesday, corned beef and cabbage on Thursday, roast beef and fish on Friday and roast beef on Saturday.

Writing in 1950, newspaperman Leslie C. Wood, who spent a fair amount of time in Monticello diners over the years, noted that the 1920 move to Broadway was not an uneventful one for the tiny lunch wagon.

"While it was being moved to the lot now occupied by the Seneca Stores in the winter of 1920, it was caught in a snow and ice storm," Wood wrote.

Early Industries

"The night of the storm it had been hauled as far as Broadway in front of the monument on the courthouse lawn. There it remained until spring."

Wood recalled that the eatery was a hot spot for banter and good-natured political heckling:

> [Scheuren] *was a Democrat and often dueled with John Curtis, editor and publisher of the* Sullivan County Republican, *who spent many a late night hour in the lunch wagon. Mr. Curtis, it is said, never went to bed until morning. His newspaper—after the big fire—was located in a small building on Bank Street, next to the Masonic Building.*

Occasionally, regular customers would turn the tables on the affable proprietor. Wood recalled a particular incident involving lemon pie:

> *It was cooked up for several* [regulars] *to go into the lunch wagon and ask for lemon pie when the schemers knew perfectly well that Mr. Scheuren had none. First one young fellow went in and asked for lemon pie. He refused anything else and walked out when Phillip named over the other kinds of pies he had. A second fellow came in and repeated the performance. Before the third conspirator could go into the lunch wagon, however, a resident not in on the joke walked in and nonchalantly asked for lemon pie. Mr. Scheuren was said to have chased him out pronto.*

Phil Scheuren was killed in an automobile accident in Florida in 1938, at the age of seventy-four. By that time, he had retired, and his son John had taken over management of the eatery. John continued until 1948, when he was succeeded by his son, Johnnie.

Of course, by that time, other diners had become well established in the village and elsewhere in Sullivan County, from Wurtsboro to Roscoe. In Liberty, for instance, where the recent arrival of the famed Munson Diner from Manhattan has been making the news of late, diners—and their predecessors, the lunch wagons—probably date back to about 1906.

Mike Engle noted that besides Daniel Sherwood's lunch wagon, which arrvied in Liberty around 1916, a place called Dan's was operating at 39 South Main Street by 1920.

Engle found an ad for Dan's from 1920. "All good things in season to eat at Dan's," the ad noted, adding that the eatery opened at 6:00 a.m.

Engle said that by 1924, Dan's may have been wheeled to another location; it was no longer at 39 South Main.

Liberty has had its share of actual diners, too, from the Miss Liberty to Lucky's to the White Bridge. But none of the Liberty diners enjoyed the longevity—or the popularity—of the Triangle Diner, which operated for nearly sixty years, becoming an early-morning or late-night fixture for doctors, police officers, revelers and celebrity entertainers from nearby hotels.

The Triangle came to Liberty in 1938, when Hymie Heller purchased what had been Cy's 9W Diner in Newburgh and had it moved to a prominent spot just outside the village most often referred to up to that time as Gerow's Grove.

Until its final demise in August 1995, the Triangle occupied the same spot, open twenty-four hours virtually every day for most of those years. It did suffer two damaging fires, one that closed it down for a month and another that idled it for twice that long, but it always reopened, better than it had been before. And although it was expanded and remodeled a number of times over the years—a lounge and a Chinese kitchen were added at different times—the Triangle retained much of its original charm. The stools, for example, were reupholstered over the years, but never changed.

Like any real diner, the Triangle had the grill right in front of the counter and what seemed like an endless string of talented grill men to make maximum use of it. The short-order cook was the superstar of the diner business and, like any true artist, could be temperamental about his craft. The more talented the grill man, it often seemed, the more temperamental he could be. George Suslosky was a case in point.

Suslosky, who manned the grill at quite a few Sullivan County diners during a career cut short by his premature death in an auto accident in 1971, was a fixture for many years at the Triangle and was known to be among the best, and the most demanding, short-order cooks in the business.

All the orders were called into the grill by the waitresses in those days. Most of them were in code, a form of verbal shorthand—"Adam and Eve on a raft" or "one in, with"—and if the waitress got the code wrong, she didn't get her food.

Sally Brady was a waitress at the Triangle for over forty years, and on the occasion of the diner's fiftieth anniversary in 1988 she remembered that Suslosky, known to friends as "George X," was particularly strict about the lingo.

"If you called in an order wrong, he'd simply ignore you," she said.

Many other grill men were the same way.

Patrons who recall the heyday of the Triangle often cite the continuity of the staff there as a significant factor in its popularity. Some—Mary

The Triangle Diner crew. George Suslosky is on the left in the rear.

Bagailick, Olga Fialowski and Ruth Watson, as well as Sally Brady—stayed for decades. That was part of the Triangle's charm and accounts, at least in part, for its longevity, despite increasing competition from new and more modern establishments.

Other diners have not been so fortunate. Take the Restop (later Sullivan) Diner, just north of Parksville. Owners had high hopes for the place when it was set on its foundation on the former site of the Prospect Inn in May 1969. "The diner came from Wayne, New Jersey in two 17-1/2 foot sections, each weighing 40 tons," Engle noted. "The diner had a capacity of 101. The owners also refurbished the nearby Gail Motel and erected a gas station. The facilities were open 24 hours and employed 65 people."

The Sullivan Diner is now closed and the building is for sale.

The Industries of W.W. Gilman

He was a member of one of America's oldest and most eccentric families and was already a wealthy man when he arrived in this area in 1846. During his nearly forty years here, he accumulated more than four thousand acres of land, employed over two hundred men, built an entire community and multiplied his fortune many times over. It was estimated at the time of his death that he was worth more than $3 million, but he died alone in a poorly furnished room.

He was Winthrop Watson Gilman, and it is unlikely that there ever existed a more peculiar character in the annals of Sullivan County history.

W.W. Gilman was born in Maine in February 1808. His father was a tanner by trade, eventually settling the family in New York City and becoming prominent in the Swamp, the section of the city dominated by leather tanners and merchants. By the time he was twenty-seven years old, W.W. was already known as the most penurious and ornery member of a family notorious for being penurious and ornery. He made his way westward that year in search of new ways to make money and ended up briefly in Cleveland, Ohio. Hearing about the possibilities of the area around Milwaukee, Wisconsin, which at that time consisted of just a few crude log cabins, he set out on horseback for the place, eventually purchasing large tracts of land there. His foresight proved admirable, and his $2,000 investment was soon worth more than $1 million.

By the 1840s, tanning had come to hemlock-rich Sullivan County in a big way, and Gilman found himself right in the middle of the boom. He purchased large tracts of land in Forestburgh, near Hartwood and Mongaup. Within a few years, he was operating a thriving lumber business in addition to the tannery. He had constructed some thirty-two buildings in a small community bearing his name, anchored by a steam-powered gang sawmill comprising twenty-two saws that turned out three to four million board feet of lumber a year, all of it shipped to New York City.

When the Port Jervis & Monticello Railroad came through the area in 1871, the community, then known as Gilman's, became Gilman's Depot (or Gilman's Station), and the train station was built onto the sawmill so that lumber could be loaded directly onto the trains. The community also included a schoolhouse, a company store, a post office and a boardinghouse.

Through all of this growth, W.W. Gilman remained reclusive, relying mainly on his son Alfred to conduct his business affairs. He also remained miserly, stubborn and often downright mean.

"Even after he was able to count his wealth by millions he denied himself the plainest comforts of life," the *New York Times* reported upon his death.

Early Industries

"It was his custom to wear a suit of clothes until the garments would barely hang together, and frequently he would appease his appetite with a piece of cheese and some crackers eaten at the homes of some of his laborers."

Gilman had a passion for driving a hard bargain and would often purchase property or articles he didn't need just because he was able to obtain them at a good price. He refused to insure any of his buildings, and when fire destroyed the entire hamlet in May 1884, he lost more than $120,000.

The fire started about a mile from the depot in the middle of the afternoon. By the time it was extinguished days later, all had been lost.

The *Times* reported the next day:

> *The wind was blowing a gale. The men from Gilman's saw mill fought the fire, but without avail. The residents were obliged to flee for their lives, and were unable to save anything and not more than half a dozen houses are standing within a radius of five miles. The fire is still burning to the east and south of Gilman's. The extensive tannery and saw mills of W.W. Gilman have been destroyed. The whole settlement is owned by him and he is unable to estimate his loss. Two railroad bridges have also been burned.*

Despite the setback, Gilman was uncharacteristically philosophical.

"If I had had policies on this property during the past 40 years the insurance companies would have been paid its entire value," he mused afterwards. "I saved that much money and had the use of it."

Alfred Gilman was nearly as eccentric as his father. He served for a time as Forestburgh town assessor, but was thrown out of office after a Sullivan County court jury found him—and fellow assessors Andrew Campbell and Bernard Cuniff—guilty of changing assessments after the time for completing the roll, and favoritism. In 1889, he was in trouble again, arrested and charged with selling oleomargarine as genuine butter. He eventually left the area to manage the family's real estate holdings in Milwaukee. W.W.'s nephew, Charles Gilman, was also involved in his businesses and served as Forestburgh supervisor from 1891 to 1893.

W.W. Gilman contracted pneumonia in November 1885 and died on December 8 of that year. Speculation as to how much wealth he had accumulated began almost immediately.

"No person knows what father is worth," Alfred was quoted as saying just before W.W.'s death. "He may be worth $500,000 and he may be worth $3 million. He is liable to buy 10,000 acres of land, or property worth half a million dollars any day and he would never tell his children about it."

In a notice of Gilman's death, the *New York Times* put the value of his holdings at between $2 and $3 million.

"It is well known that the deadman's estate comprises several very valuable pieces of improved real estate in this state and in two or three western states," the paper reported. "Mr. Gilman was a man of large brain, of keen perception, and of useful and varied knowledge. On many current topics he was a most entertaining conversationalist."

No one would dispute that W.W. Gilman was an odd yet extremely successful man. The traits seemed to run in his family; his older brother George was the founder of what was to grow into the Great Atlantic & Pacific Trading Company, or A&P, and was also known for, to put it politely, his eccentricities.

After his death, W.W. Gilman's property was sold off in pieces. His home and the 48 acres immediately surrounding it were left for the lifetime use of Andrew Campbell, a longtime employee. About 1,500 acres were purchased by Henry George's Single Tax Club, for the purpose of organizing Merriewold Park. Much of the remainder of the estate was sold to millionaire industrialist Ambrose Monell, who constructed an elaborate home and hunting and fishing preserve on it. Monell also built a new train station of native brook stone, which stands to this day, a lonely reminder of the once-thriving community of Gilman's Depot.

Making Movies

The business of making movies was changed forever in the summer of 1909, and the changes began right here in Sullivan County.

D.W. Griffith was a rising young director at Biograph Studios in New York when he brought a film crew to Cuddebackville that June to escape the city's oppressive heat. It is believed to be the first time in the fledgling industry's history that such a large group would embark on such a long journey for such a long stay. Before long, such on-location film shoots would be commonplace.

Griffith and a group that included, among others, actress Mary Pickford, actor/director Mack Sennett and cameraman Billy Bitzer, rode a ferry to Weehawken, New Jersey, took the O&W Railway to Summitville and then the branch line that the O&W had constructed (when it assumed ownership of the Port Jervis & Monticello Railroad in 1903) through Port Jervis to Cuddebackville. It was a half a day's journey. The filmmakers checked in at the Caudebec Inn—an aging three-story summer hotel that could

accommodate eighty guests—on the evening of June 26 and, shortly after sunrise the next morning, began exploring the nearby countryside for suitable locations.

In his 1970 book, *D. W. Griffith: The Years at Biograph*, Robert M. Henderson wrote:

> *The physical and geographical nature of Cuddebackville to some extent dictated the kinds of stories Griffith could film there. There were several scenic features that would add unusual touches to the backgrounds: the old canal; the Neversink River passing through the hills; impressive rocky cliffs; river rapids; a large pond in a wide place beneath one of the canal dams called "the Basin" and in the near vicinity there were several stone buildings dating back to colonial days, in reasonably good states of repair.*

On Tuesday, June 28, Griffith began work on the first of what would become known as his "Cuddebackville films," one-reelers that would help establish the grammar of film, as well as the careers of several future Hollywood notables. That first movie was entitled *The Mended Lute* and it was filmed largely in Oakland Valley, in the town of Forestburgh, about four miles from the inn. In fact, although the Caudebec Inn would always serve as the group's headquarters on their trips upstate, most of the filming was usually

A scene from *The Mended Lute*, with James Kirkwood (left) and Florence Lawrence.

done in Sullivan County. Griffith found that the unspoiled wilderness was perfectly suited to the Western and colonial themes of many of his films.

According to Henderson, that first Cuddebackville movie was a "stirring romance of the Dakotas" shot on the banks of the Neversink River, and

> *a small Indian village was constructed for a set. The cast featured Owen Moore, Florence Lawrence, and James Kirkwood. Considerable authenticity of detail was achieved by using a real Indian couple, Young Deer and his wife, as technical experts. The Indian costumes, headdresses, and equipment have a highly realistic look. The feature attraction of the picture was a canoe chase filmed on "the Basin" as well as on the Neversink.*
>
> *A second Indian picture followed—"The Indian Runner's Romance"— which was started on the second day and filmed alternately with "The Mended Lute." The second picture featured Arthur Johnson as a villainous cowboy, James Kirkwood as the Indian hero, and Mary Pickford as an Indian girl. The plot is once again a standard melodrama, but with the difference that the villains are all white, the hero who saves his Indian beloved from their hands is an Indian, and the Indian triumphs in the final chase and fight.*

Griffith and his crew left Cuddebackville on July 3, 1909, to return to the city for the Fourth of July holiday, but they would come back again and again that summer and throughout the next two. During the filming that took place in and around the tiny hamlet, Griffith experimented with many of the innovative techniques that would later become his trademark, including shooting a scene with three cameras.

A number of the frequent visitors to the area would eventually become household names in the movie industry. Mack Sennett, who made his directorial debut with a short Cuddebackville film called *The Little Darling*, later became famous for his Keystone Cop comedies. Florence Lawrence was the silent screen's first big star and the first to have her name used to promote a film. Mabel Normand became the big screen's premier comedienne. Donald Crisp, who assisted Griffith with directing chores during several Cuddebackville trips, later turned to acting and enjoyed a storied career, culminating in an Academy Award for his role in *How Green Was My Valley*. Billy Bitzer is generally regarded as the industry's first great cameraman.

But it was Mary Pickford who always stood out.

Pickford, born in Canada as Gladys Smith, not only made the transition during the Cuddebackville years from frightened ingénue to leading lady, but also began to exhibit the business acumen and movie-making instincts

that made her one of America's richest women after she cofounded United Artists studios.

Even in those early years, Pickford had an agile mind and lots of ambition, as well as talent. Henderson recalled more than one occasion in which she adeptly turned to scriptwriting to supplement her acting wages:

> *Another film was based on a scenario by Mary Pickford, "May and December," which Mary had confidently sold to Griffith for fifteen dollars...* [Henderson later quoted Pickford:] *"Surveying his squatters one day, Mr. Griffith announced he needed a split or half-reel. 'Anybody got a story in mind?' he asked. Three or four of us dashed for paper and pencil and were scribbling like mad. During my first weeks at Biograph I had quite unashamedly sold Mr. Griffith an outline of the opera "Thais" for $10. This time I ventured a plot of my own, and to the great annoyance of the men, he bought it."*

D.W. Griffith and his crew were not the only moviemakers to find Sullivan County a great place to film in 1909. Coincidentally, a small group calling themselves Bison Pictures arrived in the tiny hamlet of Neversink, on the opposite end of the county from Griffith's headquarters, that same summer.

Filmmakers Fred Balshofer and Arthur C. Miller were looking for a place to hide from Thomas Edison and his patent detectives, who were looking for royalties from anyone using Edison's camera. The company's usual haunts in Fort Lee and Coytesville, New Jersey, were too close and too accessible to New York City to effectively evade the pursuers, so the group headed farther north and west.

"Our company consisted of Charlie French, Evelyn Graham, Young Deer and his wife Red Wing, J. Barney Sherry, Eddie Dillon, Charlie Inslee, Bill Edwards, our property man, Arthur Miller and me," Balsohofer wrote in the 1967 memoir he coauthored with Miller called *One Reel a Week*.

> *At Neversink, we lived in a large, broken-down boardinghouse, and fixed up the side of a barn for use as our interiors when needed. We hired local residents as extras, turning them into cowboys or Indians by the use of makeup. The imposing Catskill mountain scenery, with cowboys and Indians riding like the wind over hill and dale and splashing through streams, combined with the clear mountain air, made it possible to get sharp, brilliant photography, which boosted the sale of the Bison films, but also kept us the main target of the Patents Company. We remained at Neversink until the snow began to fly; then we returned to New York.*

Charles "Charlie" French (left) and Evelyn Graham with an unidentified actor, possibly a local, in an unnamed 1909 movie filmed in Neversink.

Like Balshofer, Griffith loved the mountains, but he was frustrated that the summer seasons here were so short, and his production while at Cuddebackville was often curtailed by the weather. Beginning in 1910, he followed up his trips here with excursions to California, where he eventually discovered similar scenery and weather more to his liking. He left Cuddebackville for the last time on August 3, 1911, having perfected a number of innovative filmmaking techniques, and was well on his way to establishing himself as "the man who invented Hollywood."

THE TANNERIES

As incongruous as it may seem, the Civil War was good to Sullivan County. At least from an economic standpoint.

The tanning industry, which had migrated to Sullivan from Ulster and Greene Counties as the hemlock trees were depleted there beginning in the

late 1830s, blossomed during the war years. An unprecedented demand for leather for boots, bridles, holsters and belts forced every tannery to work at capacity. The army actually preferred the peculiar red leather tanned in Sullivan County, for it was said to be more supple and durable than most.

By the time Fort Sumter was fired upon, there were tanneries in virtually all of the fourteen towns that then made up Sullivan County. Only Highland and Tusten did not have tanneries within their borders. In 1860, over $7 million worth of tanned leather was manufactured in the Catskills region of New York State, more than half of that coming from Sullivan County. In 1865, thirty-nine Sullivan tanneries turned out over 8.5 million pounds of leather, worth more than $2.6 million.

The tanneries came in all shapes and sizes, employing anywhere from a handful to several hundred men. According to *Brass Buttons and Leather Boots: Sullivan County in the Civil War*, published in 1963 by the Sullivan County Historical Society, the Palen tannery at Neversink Falls (present-day Old Falls) was one of the largest of the early tanneries, with a main building that measured 40 feet by 350 feet. This operation, built in 1832, used over four thousand cords of hemlock bark a year and employed forty men in the tanning process and many more cutting and stripping the trees.

"The Claryville tannery, built in 1848, was even larger," according to the book. "It employed 50 men and tanned 30,000 sides of leather annually."

The Kiersted Tannery in Mongaup Valley was also built in 1848 and was one of the most successful and efficient of all the local operations. In fact, it was the hub of the thriving hamlet, which, like many communities in the county, grew up around the tannery operation.

In his *History of Sullivan County,* James Eldridge Quinlan noted that until 1847, the place was known as Mongaup Mill, "a grist mill having been built by the Livingston family at the point where the Newburgh-Cochecton Turnpike crosses the Mongaup River. Great Lot 15 was owned by that family," he wrote, "and finally passed to the children of John C. Tillotson, whose wife was a Livingston. In 1807, five families were living in the valley or its neighborhood. Forty years later, there were but four dwelling-houses in the place, and about 25 inhabitants."

The Kiersted Tannnery changed all that.

The late Delbert Van Etten, longtime historian of the town and village of Liberty, wrote extensively about the tannery in the Sullivan County Historical Society's *Observer* in 1984.

Wynkoop Kiersted was born in Saugerties in 1818 and had operated tanneries in both Greene and Ulster Counties before coming to Sullivan

County. Van Etten wrote that in 1847, Kiersted and his brother John had "entered into a contract which had secured the hemlock bark on a tract of about 10,000 acres of land in the Mongaup Valley known as the Tillotson Tract."

The Kiersted brothers and Wynkoop's father-in-law, John W. Swann, built the tannery, which began operation in October 1848. Just a few months earlier, the tiny community of Mongaup Valley had been granted a post office, with Wynkoop Kiersted its first postmaster.

Hamilton Child, in his *Gazetteer and Business Directory of Sullivan County for 1872–73*, wrote that the tannery used the rushing waters of the Mongaup for its power. "[It] is admitted to be the model tannery in the county," Child wrote. "Perhaps it would not be extravagant to say this of it in respect to the whole country, for its internal arrangement and the various processes employed in its manufacture are characterized by such neatness, fitness, and convenience as is consistent with the business and in striking contrast with most establishments of the kind."

The main building of the tannery complex was 410 feet long by 40 feet wide and three stories high. It was the largest of the buildings in the complex, which also included a Leach House, a Steam House and a Bark House, which measured 400 feet by 22 feet. The tannery employed a minimum of fifty men—another ninety were added during bark-peeling season—and provided housing for many of them. A number of these men were brought over from Ireland by Wynkoop Kiersted specifically to work in the tannery.

Quinlan wrote that the success of the operation soon led to the "building of dwellings and places of business which are second to none." The most elaborate of these dwellings was constructed by Wynkoop Kiersted himself just off the Newburgh–Cochecton Turnpike, about a mile from the business. The large home, topped by a cupola, was surrounded by spacious lawns and a white picket fence. There Kiersted took up residence with his wife Jane and four children.

By 1859, Mongaup Valley had 664 inhabitants—365 of them twenty years of age or younger. Quinlan pointed out that 477 of these residents "were born in the United States, 167 in Ireland, and 20 elsewhere. 277 were Roman Catholics."

Van Etten noted that in 1856 the tannery "with an overhead of $12,000 turned out 50,000 sides of leather valued at $187,000." And Child recorded that between 1848 and 1872, the tannery grossed over $3.3 million.

Child wrote that in 1870, Mongaup Valley had three hundred inhabitants, two churches, two stores, one hotel, one gristmill, one sawmill, three

The tannery in Monticello was the only Sullivan County tannery to survive to the twentieth century.

blacksmith shops, one shoe shop, one wagon shop, one harness shop and "an excellent high school" in addition to the tannery. By comparison, the village of Monticello had a population of about one thousand in 1870.

Of course, the depletion of the hemlock forests eventually ended the heyday of the tanneries throughout the county, and Kiersted's was no exception. An article in the October 13, 1882 edition of the *Republican Watchman* newspaper reported that the operation was "on its last legs," and most of the tannery complex was destroyed by fire in 1887. Wynkoop Kiersted died three years later.

Tanners in general had been concerned only with the present and paid little attention to the future. This proved ruinous, for many who had made their fortunes in tanning were penniless by the 1880s. Only the tannery in Monticello, originally built by E.L. Burnham and later owned by Strong, Starr and Company lasted into the twentieth century. It burned to the ground in 1924.

TIMBER RAFTING

Whenever the Delaware River overflows its banks, it indelibly ingrains in observers the awesome power of nature. For those of a historical bent, it also serves as a reminder of how swiftly the river must have run in days gone by, when, it is said, timber rafters could journey from Cochecton to Philadelphia in as little as forty-eight hours.

Timber rafting was once the linchpin of the area's economy. It was the first industry to develop in the wild, desolate region that is today known

as Sullivan County, predating both the tanning and bluestone industries by more than half a century.

The practice of felling trees and floating them down the Delaware for sale in Philadelphia started just after the French and Indian War. Daniel Skinner, who came here from Connecticut in 1755 with his parents and siblings—his father, Joseph, killed in 1759, is believed to have been the first white man murdered in the upper Delaware region—is generally regarded as the man who started it all. The earliest trips downriver, however, were not without incident.

It was on a trip to the West Indies, historians note, that Daniel Skinner first got the idea of floating the tall, straight pine trees from along the banks of the Delaware to the Philadelphia shipyards.

"He had purchased of his father twenty-five acres of land near Damascus, known as 'Ackhake.'" wrote Leslie C. Wood in his 1950 history of timber rafting, *Holt! T'Other Way!* "On returning from his voyage, he cut, trimmed and rolled into the water several of the tallest pines and followed them down the stream in a canoe. Failure marked the venture. The timbers either became lodged in inaccessible places or were lost in the long eddies."

So Daniel Skinner conceived the idea of lashing the trees together to form a raft, which could be ridden and steered down the river. He made his first successful trip in 1764.

"After felling six large masts of equal length, he cut a mortise four inches square through both ends of each, rolled them into the water, and inserted what he called a spindle through the mortises," Wood noted. "He placed a stout pin through the ends of the spindles to keep the logs from slipping. By using cross-logs on each end of the craft, he hung a large oar (in the center) fore and aft. He called the result a raft."

Skinner hired a man named Cudosh to accompany him on the journey to Philadelphia on this raft, and it took them over a week to complete the trip from St. Tammany's Flat, just below Callicoon. Upon arriving in Philadelphia, Skinner was paid four pounds per mast.

A second raft, containing ten spars and five feet wider than the first, was then constructed and floated downriver in just two days. Soon, there were dozens of other daring, hardy men engaged in the same practice, each of them paying homage to Skinner as "the Lord High Admiral of the Delaware."

"By general consent, [Skinner] was constituted Admiral of all the waters of the river in which a raft could be taken to market, and no one was free to engage in the business until he had the Admiral's consent," wrote James Eldridge Quinlan in his *History of Sullivan County*. "This was gained

by presenting Skinner with a bottle of wine, when liberty was granted to the applicant to go to Philadelphia as a forehand. To gain the privilege of going as a steersman, another bottle was necessary, on receipt of which the Admiral gave full permission to navigate all the channels of the river."

It didn't take long for those who regularly rafted the river to realize that spring was the optimum time for making the trip, which could usually be accomplished in about three days.

Wood continued:

> When the ice had gone out and the spring freshet was in the offing, great was the excitement and activity along the river. The raftsmen began placing timber into their rafts, and the women folks started preparations for sending their men on their way. The women [baked] a large multitude of bread, pies, cakes, apple turnovers, and other delicacies for the huge dinner-bucket from which the rafting crew would eat its noontime meal while floating down the river. Once the rain started to fall, the men set out empty pails to note how fast the water arose in them or cut a sapling, notched it and pushed it down into the gravel of the river bed with the mark at the surface. They measured the rate at which the stream was rising as the water deepened over the notch.

At first, rafters cut only pine trees of a particular height and straightness from the riverbank, but by the heyday of the rafting industry in the 1870s, all types of timber, much of which would have been disdained by earlier harvesters, was being cut from as far away as Livingston Manor and beyond. Feeder streams, such as the Beaverkill and the Lackawaxen River, were used to get the timber to the Delaware. The narrow, twisted nature of these smaller streams usually dictated that the logs be floated individually or as "colts," small rafts that were later gathered together in groups of four or six to constitute a full-sized raft when they reached the Delaware.

Not every stream was conducive to rafting, though. Otto William Van Tuyl and his ill-fated Neversink Navigation Company found that out the hard way. The company was formed in 1816 for the purpose of opening the Neversink for rafting, and charging others a toll for getting their lumber through to the Delaware.

"If the company had succeeded in making the river navigable, its revenue would have been princely," Quinlan noted.

Van Tuyl borrowed $10,000 from New York State and commenced "improving" the river. His first two rafts wrecked, and one of his men drowned.

"Although the enterprise resulted in poverty and reproach to Van Tuyl," Quinlan recorded, "he never lost confidence in it, and continued to make futile attempts to improve the river, until the State foreclosed its mortgage."

PART IV

PLACES
FROM THE PAST

BARRYVILLE

John Willard Johnston was a surveyor, lawyer, historian and the Town of Highland's first supervisor, but he was not much of a prognosticator, at least not with respect to Barryville.

Johnston, whose prolific writings were collectively published under the title *Reminiscences*, lived in Barryville from 1856 until 1887, when he moved to Narrowsburg. In his own inimitable style, he wrote extensively of the community, its growth, its demise and the people he deemed responsible for both, particularly the latter.

Barryville grew up around the D&H (Delaware and Hudson) Canal. It was named for William T. Barry, the nation's first postmaster general. By 1844, it had a population of about three hundred; because of the canal and a thriving lumbering business, the town was important enough to be seriously considered as the county seat when fire destroyed the county buildings in Monticello—sentiment among the supervisors was strongly against rebuilding them in the village.

That may have been, in Johnston's view at least, the heyday of the hamlet. He wrote that the demise of the community began with the departure of Gardner Forgerson to Goshen in 1850. Forgerson, who owned "the village site and in all direction around it, and doing business therein, conceived it his interest to gather as many people in and around it as possible; a sound rational view, and hence he was anxious to sell lots, encourage persons to build and settle in the place."

Not so the businessmen to whom he sold—Chauncey Thomas, James K. Gardner and Elias Calkin. Johnston said these three "adopted a resolution

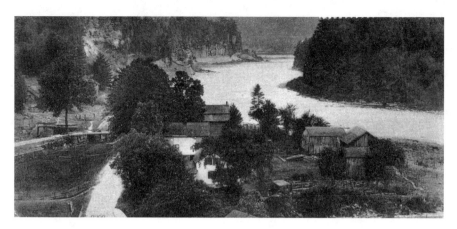

Barryville, circa 1900.

that they would not sell a building lot for any price or upon any conditions—they would keep what they had, seek no more, and shut all others out."

Johnston said he once asked Calkin the reason for the closed-door policy and was told that "the owners of houses and lots would keep hens."

Johnston did not try to hide his disdain for these men and their attitude, and he was even harsher in describing their heirs, Stephen St. John Gardner and Oliver Calkin.

"I am disposed to question if two more inefficient men in the business relations of life are treading the earth today," he wrote, "especially if the management of the Barryville property be selected as an example. It is quite unnecessary to specify, since relaps [*sic*], dilapidation, and decay appears from every quarter and in every feature of their possessions."

Still, it was Gardner who, as president of the Barryville-Shohola Bridge Company, stabilized the suspension bridge connecting the two hamlets after several calamitous collapses. The bridge, opened in 1856, operated until 1941.

Around the turn of the century, Johnston noted that Barryville

> *is a small poor village now. The lumber of the region being exhausted, the business of canaling declining and now abandoned, it has for the last 25 years been waning, until now it seems to have reached a bottom of hardpan.*
>
> *Human imagination can hardly reach anything in* [the] *future likely to improve it; but it will probably remain indefinitely the small poor place it now is.*

He did not envision the role the Delaware River, and the Erie Railroad, would play in the development of another great industry in the valley: tourism. By 1899, places like the Spring House in Barryville—a historic structure meticulously restored in recent years—were offering tourists "an excellent waterfront, well shaded lawns, and everything conducive to the health and comfort of guests."

The railroad was promoting the entire upper Delaware Valley as a "sportsmen's paradise," and Barryville, as well as the other small communities around it, prospered.

Of course, tourism has always had its ups and downs, and while there have been good times and bad since Johnston put down his acerbic pen, or quill, for good in 1911, he likely would not recognize the place today. A committed group of newcomers has combined with established residents to spearhead a rebirth that includes the River Road Street Fair, originally conceived by longtime resident Eleanor Burrell and now celebrating its twelfth year.

The Barryville Chamber of Commerce recently became active in promoting the area as a four-season destination and has created an information station at the intersections of Route 97 and 55.

The restoration of the Lord Baltimore filling station that dispensed Amoco's unique "white gas" as far back as the 1920s was made possible through a grant from Sullivan Renaissance and the devoted efforts of a handful of volunteers.

John Willard Johnston would never believe it.

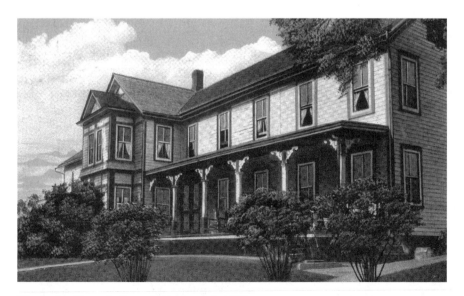

The Spring House in Barryville in the early 1900s.

CRAIG-E-CLARE

The tiny, picturesque hamlet of Craig-e-Clare hugs the banks of the Beaverkill and is home to some of the most amazing scenery in the region, as well as one of the most unusual landmarks.

As far back as the middle of the nineteenth century, sportsmen from around the country were attracted to the area by its natural beauty, and prior to 1920, multimillionaire Ralph Wurts-Dundas began construction of an impressive castle overlooking the Beaverkill. Both the natural beauty and the castle remain largely intact today.

But what about the name, Craig-e-Clare? What is its origin and what does it mean? Most people hearing about it for the first time want to know more about the tiny community with the unusual name.

Craig-e-Clare was granted its own post office in 1896, with Adelia Cammer the first postmaster. The post office was discontinued in 1914, but the unusual name stuck, though few people remembered how it originated.

Ed Van Put supplied some of the answers in his wonderful 1996 book, *The Beaverkill*:

> *There is a section of the Beaverkill, located midway between the hamlets of Beaverkill and Rockland, known as Craig-e-Clare. Today it is not much more than a name on a map, at a bridge crossing. But there was a time when it was more populated, when it had its own post office, and a stately stone castle—in which, it was rumored, lived a beautiful and seductive woman who enticed fishermen from the stream into her extravagant fortress.*
>
> *Known as the Dundas Castle, the building with the mysterious past sat high on the bank overlooking the Beaverkill. It sits there still, though through neglect, mature trees and other forest vegetation now shield it from public view.*
>
> *In 1891, Bradford L. Gilbert, a noted New York City architect, began acquiring land in the area. He amassed several hundred acres and constructed a beautiful summer home, known as Beaverkill Lodge.*
>
> *Gilbert's wife was a native of Ireland, and the steep hillsides and rapid flowing stream so reminded her of home, that in 1896, when the new post office at the tiny hamlet was to be named, she selected Craig-e-Clare. This was the name of her small Irish village and translates to "Beautiful Mountainside."*

More details about the estate of Bradford Lee Gilbert are found in a one-hundred-year-old newspaper article, recently reprinted in the *Walton Reporter* and brought to light by Alice Hodge, a longtime resident of Craig-e-Clare.

The article is headlined, "Visit to Beaverkill Lodge: B.L. Gilbert's Country Residence at Craigeclare [*sic*] one of the Finest in America," and goes on to relate the impressions of a newspaper reporter who was provided a tour of the Gilbert property.

"Sullivan County has been noted for years as the summer home of the city resident," the article began. "Probably there are as many people who sojourn within its confines during the months of June, July, and August as any other county in the state. The county contains many fine residences, the number of which is fast increasing each year."

The article noted that the reporter was accorded every courtesy as the architect escorted him through "the numerous rooms of his mansion and conducted him to the places of interest on his vast estate."

After noting Gilbert's renown as the designer of many fine buildings, including Grand Central Station, the article recalled that Gilbert "came to Craigeclare [*sic*] twelve years ago and is the pioneer city man of that section. He has purchased several adjoining farms and tracks, so that today his estate comprises several hundred acres."

The article told the same story about the naming of the community that Ed Van Put relates, and further noted that

> *Mr. Gilbert's residence is located on high ground and the view from the front plaza is magnificent. From this point one can catch a glimpse of mountain, hill, and dale, and forty feet below, at the bottom of the cliff, which rises almost perpendicular, can be seen the turbulent Beaverkill.*
>
> *All of the rooms* [in Beaverkill Lodge] *are supplied with water, heat, electric light, telephone, call bells, and every other convenience, all of which were designed by Mr. Gilbert himself. His system of baths is worthy of description. He has designed that his guest shall first play the game of squash, a game of English origin which is played in a fine court adjoining the bath. After the game, the player takes the electric douche, needle and plunge baths in succession and in the order named. The finishing touches are added in the "Rest Room" which is a superbly appointed compartment among the striking features of which is the frescoing of birch bark and scores of handsome mottoes on the walls, indicative of rest and ease.*
>
> *Mr. Gilbert contemplates building an automobile road to Rockland. He is negotiating for the purchase of an abandoned highway and if he is successful, he will construct one of the finest private roads in the county.*
>
> *He designs to make* [his home] *one of the most complete country estates in America, particularly in the details that add to comfort and convenience.*

Bradford Lee Gilbert died in 1911, and much of his land was sold to silk magnate Morris Sternback. Ralph Wurts-Dundas purchased his property from Sternback in 1915 and began construction of his castle shortly thereafter. Sadly, he died in 1921, before the building was completed, and since his wife (and later his daughter, as well) had been confined to an institution due to mental instability, no one ever lived in the magnificent stone structure. Unless, of course, you believe the legends that began to circulate in the 1930s of the seductive woman with the long blond hair who regularly lured unsuspecting fishermen to an afternoon's adventure.

"Rumor had it that the sole occupant was a beautiful but demented young girl, who used to let down her golden hair from an upstairs window and lure unwary anglers into her granite castle, for what probably amounted to nothing worse than an afternoon's pleasant seduction," recalled Corey Ford in Leonard M. Wright Jr.'s 1990 book, *The Fly Fisher's Reader.* "I fished past Craig-e-Clare, hopefully, a number of times, but I never got lured."

DeBruce

The hamlet of DeBruce is notable for a number of reasons, including the fact that it was once home to one of the area's largest tanneries and, perhaps incongruously, for the significant role it has played in the history of tourism in Sullivan County.

Originally named for Elias DesBrosses, who purchased Great Lot no. 5 from the heirs of Peter Faneuil, a patentee of the Hardenbergh Patent, the tiny hamlet is situated at the confluence of the Mongaup Creek (not to be confused with the Mongaup River) and the Willowemoc. It is this location that has provided it with much of its history.

In his *History of Sullivan County*, James Eldridge Quinlan noted that the area was "a tangled jungle" in 1856, when Stoddard Hammond and James Benedict arrived on the scene.

"In that year Hammond and Benedict contracted with John Hunter, Junior, [then the owner] for the bark on thirty-five thousand acres of land and commenced the building of one of the most extensive sole-leather tanneries in the county," Quinlan wrote. "This tannery cost $70,000 and is of sufficient capacity to manufacture sixty thousand sides of leather annually. It gives employment to from fifty to one hundred men, and it has added vastly to the importance of the section in which it is situated."

Stoddard Hammond bought out his partner in 1864 and renamed the tannery Hammond & Son.

"All of the hides used by these early tanneries came from Argentina," Joseph F. Willis told us in his abbreviated history of the town of Rockland, *The Pioneer*, published in 1939. "Three main outlets extended from DeBruce: east on the Pole Road to Claryville, south over the hill to Parksville, and later north to Roscoe and down the Gulf Road to the Erie Railroad at Callicoon."

Hammond also built an acid factory at DeBruce and his son later erected one at Willowemoc. All of these enterprises suffered financial reversals, and the Hammonds lost much of the considerable fortune they had accumulated. Still, their businesses served as the linchpin of the local economy, and DeBruce grew up around them.

The hamlet received a post office in 1860, with Stoddard Hammond Jr. the first postmaster. According to Hamilton Child in his *Gazetteer & Business Directory of Sullivan County for 1872–73*, in addition to the tannery, DeBruce comprised a store, a school, a blacksmith shop and eighteen dwellings in 1870, with a population of 150.

"The tannery at this place is one of the largest in the state," Child noted. "It consumes about 6,000 cords of bark and tans 60,000 sides of leather annually."

The post office officially changed the spelling of the hamlet from DeBruce to Debruce in 1894 and then was finally discontinued in 1945.

DeBruce's location at the point where the Mongaup Creek emptied into the Willowemoc also made it a popular fishing destination. As famous as the Willowemoc has become, the Mongaup Creek was, for a long time, more highly regarded as a trout fishing stream. The famed naturalist John Burroughs, for instance, considered it more productive.

The trout not only attracted fishermen, but wild animals as well. Long after the panther had disappeared from other parts of Sullivan County, legend had it that the monstrous DeBruce panther prowled the area every April and May, feasting on trout and tourists.

By 1899, the area had a rich tradition of attracting sportsmen (and women) to play tennis and golf, as well as to fish. Elizabeth Royce's Hearthstone Inn, which prided itself on its well-kept tennis lawn, accommodated fifty guests; Miss Ada Cooper's, which advertised golf grounds on the premises, could house sixty. Smaller establishments included the Sheely House and John O'Keefe's Mountain Spring House.

Ed Van Put noted in his recent book, *The Beaverkill*, that both the Hearthstone Inn and Miss Ada Cooper's, also known as the Homestead, were acquired by Charles B. Ward, who "consolidated these holdings into a 1,300 acre estate, which included 2-1/2 to 3 miles of the Willowemoc and

A very rare photo of women playing tennis at the Hearthstone Inn in DeBruce.

Mongaup. For many years he operated a popular fishing hotel known as the DeBruce Club Inn."

Another prominent landowner in the vicinity was John Karst, a well-known wood engraver, who illustrated, among other books, the original McGuffey Readers. Karst was a wealthy and cultured man, and he collected rare books, antiques and furniture. Following his death in 1922, his daughter Esther conducted his home as a museum.

Van Put noted that Esther became embroiled in a controversy that played itself out in local newspapers, creating quite a stir.

"At issue was her desire to change the name of Mongaup Creek," Van Put noted, "an idea that incited not only local residents, summer residents, and former residents, but even nonresidents."

The trouble began when Esther wrote to the *Livingston Manor Times* weekly newspaper, innocently suggesting a name change, to avoid confusion with the Mongaup River, an idea supported, at least in principle, by the New York State historian. She invited readers to come up with an alternate name and began circulating a petition.

A number of names were bandied about, including Hunter Creek, Mountain Creek, Wild Orchid Creek and even Esther Creek. Eventually, however, Esther Karst failed in her bid to rename the creek. Apparently locals

forgave her, Van Put wrote, for she is remembered, perhaps immortalized, by the beautiful waterfalls of the Mongaup, which are still known today as Esther Falls.

LOCKWOOD MILLS (FALLSBURG)

It is easy to remember the hamlet of Fallsburg, commonly known at present as Old Falls, strictly for the numerous resorts that once dotted the roadside there, but its history is much more diverse than that.

As was the case with several other hamlets in the county, the very body of water that made Old Falls a popular tourist destination in the early twentieth century first made it a booming industrial center a century before. In this case, that body of water was the Neversink River, or, more precisely, the Neversink Falls, the twenty-three-foot drop that provided not only the name of the hamlet, but that of the township itself.

James Eldridge Quinlan speculated in his 1873 *History of Sullivan County*, that "the water power of Fallsburgh [the "h" wasn't officially dropped until 1968] is almost inexhaustible, and with enterprise and capital sufficient to render it available, may yet add immensely to the population and wealth of this town."

By the time Quinlan was writing, the hamlet had a number of thriving industries and had even lost one of its most lucrative, the tannery adjacent to the falls. (In fact, when the tannery in Sandburgh later burned—on November 6, 1871—the town of Fallsburgh, the site of some of the earliest tanneries in the county, was left without a single tanning operation within its borders.)

Prior to that, according to Hamilton Child in his *Gazetteer and Business Directory for Sullivan County 1872–73*, tanning "was one of the leading branches of industry" in the town of Fallsburgh. And one of the principal tanners, Rufus Palen, was among the most important and influential men in the town's history.

Palen came from a family of tanners in Ulster and Greene Counties. He arrived in Fallsburgh in 1831, and with his partner, Matt Adams, established one of the first tanneries in Sullivan County, utilizing the falls for power and the water from the river to treat the hides. The Palen tannery was able to tan from ten thousand to fifteen thousand hides, but it was soon outpaced by other tanneries capable of turning out thirty-five thousand hides or more. Nonetheless, it ranks as one of the longest-running tanneries in the county's annals, and one of the few that never had a serious fire, a fact no

doubt attributable to the peculiar rule Rufus Palen strictly enforced against smoking on his premises.

When Palen and Adams arrived at the falls in 1831, there was already a thriving industrial community, largely due to the efforts and investments of Thomas S. Lockwood. Lockwood was so influential that, by 1816, the hamlet, long called Neversink Falls, had become known as Lockwood Mills, and when the town of Fallsburgh was formed from Thompson and Neversink in 1826, the first inclination was to name it Lockwood; this would have been done, except for the protestations of the man himself, who, Quinlan recorded, "thought no resident was entitled to the honor of having his name thus perpetuated."

Lockwood was from a prominent Newburgh family. Quinlan noted that "when Lafayette visited the United States in 1824, he opened a ball given in his honor with a daughter of Mr. Lockwood as his partner."

When he came to this area, Lockwood bought out the saw- and gristmills built in 1808 and 1809 by Henry Reed and Herman Ruggles. He also purchased the mill of Jacob and Thomas Powell. As Quinlan wrote, Lockwood "accomplished much in developing the natural resources of the Falls. He erected buildings, and induced others to settle in the place." He eventually owned five mills at the falls, including a paper mill.

The paper mill of Thomas Lockwood is visible through the arch in the bridge over the Neversink River.

Lockwood was instrumental in the construction of the Ulster–Orange Branch Turnpike, which was chartered in 1808 and completed in 1818, and in the construction of the stone arch bridge built in 1819 (it was destroyed in 1952 to make way for a "more modern" structure). The turnpike, which much aided development and settlement of the town, began at the Newburgh–Cochecton Turnpike in Montgomery, passed through Burlingham, Roosa Gap, Summitville and Sandburg and finally ran through Old Falls and on to Liberty. The roadway was constructed with funds obtained by taxing the landowners who resided within five miles of it. When many of these landowners were unable to pay the resulting property taxes and their parcels were auctioned off, Lockwood bought thousands of acres at the tax sale. He owned over ten thousand acres of land at his death in September 1837.

The year after Lockwood's death, Rufus Palen was elected to Congress. As a consequence of this, Edward and Arthur Palen and their cousin, Nicholas Flagler, became active in the Palen tannery at the falls, which soon became known as Palen & Flagler. It survived Rufus Palen's death (from tuberculosis), and thrived during the Civil War, but was shut down shortly thereafter because of a lack of bark.

By that time, the hamlet of Fallsburgh, as it had become known, comprised a church, two stores, two sawmills, a gristmill capable of processing two hundred bushels of grain a day, James B. Gardner's Fallsburg Light Carriage and Sleigh Manufactory, a cigar factory, two blacksmith shops, one harness shop, one district school and one select school. Its population was about 130.

In 1872, Carrie Flagler Angel, daughter of Nicholas, began operating a small hotel called the Flagler House on a knoll adjacent to the river. Although the New York & Oswego Midland Railroad located its station about three miles south of the hamlet of Fallsburgh, spelling the eventual demise of industry there, Carrie Flagler Angel's business thrived. Tourists just loved the Neversink Falls. Other boardinghouses, such as William Johnson's, followed. By 1895, the Flagler had room for seventy and was offering guests lawn tennis, croquet and large well-shaded grounds, for ten to fourteen dollars per week. When Asias Fleisher and Phillip Morganstern purchased the hotel in 1908, they made even more improvements. By 1920, the hotel had become the most famous in a county that was famous for its hotels, and the hamlet of Fallsburgh was about to be reincarnated as the center of a bustling resort industry.

KIAMESHA LAKE

The demolition of the fabled Concord Hotel, and the elaborate plans developers have presented for replacing it, has focused attention on what was once Sullivan County's largest resort, as well as on the hamlet in which it was located.

Whether known as Pleasant Pond, Pleasant Lake, Kiamesha or Kiamesha Lake—the hamlet has had all those designations attached to it over the years—the community has long been one of the county's premier tourist destinations. This has been true since the late nineteenth century, when Pleasant Lake, as it was then known, was surrounded by, as Edward F. Curley points out in his book, *Old Monticello*, "the old and well known boarding houses of the Strangs, Trowbridges, and Conways." Even through the early 1900s, the area was dominated by the rambling Kiamesha Inn, C.M. Bartlett's large Pleasant Lake House (later the Kiamesha Lake House) and the adjacent Bonnie Golf Links; on into the 1950s, the Concord took its place at the very top of the list of 538 Sullivan County hotels.

The poet Alfred B. Street long ago wrote of the majesty of the crystal-clear waters and the lake's renown as a picnic spot for locals. One of the earliest man-made attractions to draw tourists to the lake was the casino, originally built by D.S. Yeomans.

Curley wrote that Yeomans, "then a resident of Monticello, purchased a parcel of land next to the Van Antwerp property and erected a large casino

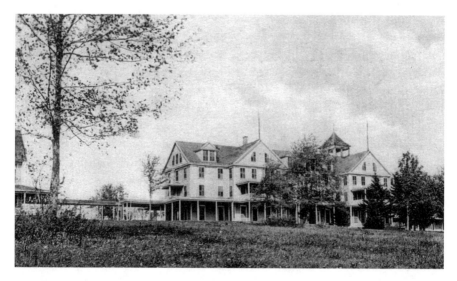

The Kiamesha Inn.

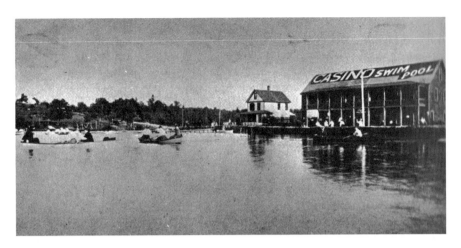

The Kiamesha Casino, circa 1900.

building, installing a large swimming pool, billiard parlors, bowling alleys, dancing pavilion, etc. This enterprise proved to be a good investment, as it was and is still patronized by thousands of the summer visitors."

Of course, the hamlet would likely have proven even more popular with tourists had the long-discussed yet never-built Fallsburgh, Monticello & White Lake trolley line ever been completed. Several groups of entrepreneurs attempted to link the three communities, and those en route, by traction railway, even obtaining rights-of-way and clearing land, but the line was never constructed.

Despite its lack of direct rail service, Kiamesha thrived as a resort area and was heavily promoted as such by the O&W Railway, which encouraged visitors to reach the destination by disembarking at the station in South Fallsburg.

The railway, whose promotional efforts were largely responsible for the growth of tourism in the county in the years leading up to the Silver Age, issued a special timetable for service to Kiamesha Lake in 1899:

This beautiful sheet of water, formerly called Pleasant Lake, now called by its original Indian name, meaning clear water, is two and a half miles from Fallsburgh station. It is 1600 feet above the sea, and nestles at the foot of Old Round Top Mountain, from the summit of which a grand view is obtained. The lake is one mile long by three-quarters wide, of pure spring water, clear as crystal. It is well-stocked with black bass, and the fishing is excellent. The east side of the lake is heavily timbered, and the shores edged with white and pink laurel. Splendid macadam roads afford delightful

driving and bicycling. About the lake are some fine hotels, boarding houses, and private cottages.

As the Silver Age ended around 1915 and the county began its transition to the great resorts of the Golden Age, those "fine hotels, boarding houses and private cottages" faded from view, to be replaced by larger, more modern resorts like the Kiamesha Mansion, the Kiamesha Country Club, the Savoy, Gluck's Hillside, Gibber's and the Ideal Plaza.

By the time Russian immigrant turned hair tonic magnate Arthur Winarick bought the Ideal in 1935, and began construction of what he envisioned as the world's largest hotel, the lake itself had become considerably less important to the tourism trade. By that time, hotels were offering their guests more refined amenities, and swimming pools were becoming obligatory attractions.

Besides, the village of Monticello had seized control of the entire lake as the longtime source of its drinking water, and swimming had been banned.

Under Winarick's direction, the Ideal Plaza became the Concord Plaza, with accommodations for five hundred guests in 1937; then in 1941, it

An aerial view of the Concord Hotel, "the Acropolis of Sullivan County."

The indoor pool at the Concord made Kiamesha Lake inconsequential to guests.

became the Concord, with facilities for eight hundred; and by 1946, it was advertising itself as the New Concord, with "a lounge and cocktail bar... cabaret and nightclub with professional entertainment on the premises." Shortly thereafter, it was again just the Concord.

By 1970, the hotel offered forty-five holes of golf, indoor and outdoor skating and swimming, a large tennis complex and much more. Perhaps Manville B. Wakefield summed it up best when he wrote what could serve as the hotel's epitaph in *To the Mountains by Rail*:

> *The Concord, one of the largest resort hotels in the world, exemplifies the independence of a modern resort to its site. The lake makes little difference to the hotel, which boasts lake-, or at least pond-sized outdoor and indoor swimming pools. To entice winter sportsmen, the resort also offers indoor ice skating and snowmaking machines to augment nature's supply on the ski slopes. Driving to Kiamesha from Monticello, you pass the lake; and across from route 42, crowning a hill, is the Concord with its main building designed by Miami's Morris Lapidus, a hotel which many consider the Acropolis of Sullivan County.*

JEFFERSONVILLE

The area of Sullivan County known today as the village of Jeffersonville was originally settled in the 1830s, and by the 1840s it had become home to a large population of German and Swiss immigrants who called their community Winkelried.

James Eldridge Quinlan, in his *History of Sullivan County*, wrote that "in 1847, it was estimated that two hundred and fifty German families were in Cochecton, Callicoon, and Fremont, and in 1855, the State census shows that of the 2,649 residents of that nationality in Sullivan, 1,924 were in those towns. In addition to these, there were 171 from Switzerland in Cochecton and Callicoon." The town of Delaware had yet to be formed.

Quinlan noted that much of the credit for the influx of German and Swiss families to the area belonged to Monticello businessman Solomon Royce, who had printed "large numbers of circulars and handbills in the German language, in which were set forth the advantages of settling in the northwest section of Sullivan."

Royce became a wealthy man because of his speculation in developing the lands of the Callicoon region and stimulated the growth of what was to become one of the county's largest communities.

Charles F. Langhorn also helped fuel the growth of the area by building the first hotel in the as-yet-to-be-named settlement in 1846. Langhorn suffered from some pulmonary ailment and had been told by his doctor to settle in an area abundant with hemlock trees, so he chose that sparsely settled part of Sullivan.

"The future village at that time was nameless, and was little better than a rude clearing in the woods," Quinlan recorded. "Nevertheless, the idea prevailed that it would speedily become a place of importance, and to this idea probably Jeffersonville owes its existence."

Langhorn called his hotel the Jefferson House, and as the community grew up around it, "the name followed as a natural consequence," Quinlan wrote. Langhorn's hotel was the first building painted in the area, and it was so substantially built that with some repair it was still operating as late as 1871, under the ownership of the Egler brothers. Langhorn, however, was not successful in the business, which was apparently ahead of its time.

In the 1870s, Jeffersonville was home to a German language newspaper, the *Sullivan Volksblatt*, as well as its own weekly, the *Local Record*, which was originated in Callicoon in 1868 by W.T. Morgans, later a well-known inventor. The paper was moved to Jeffersonville in 1870 and was published there by D.J. Boyce and A.P. Childs.

Places from the Past

By 1870, Hamilton Child reported in his *Gazetteer and Business Directory for Sullivan County* that Jeffersonville had grown to include four churches (Catholic, Methodist, Presbyterian and Reformed), three hotels, six stores, a printing and newspaper office (the *Local Record*), one sawmill, two gristmills, two wagon shops, one brewery, one furniture store, a tannery, two harness shops, one mineral water manufactory and a school. Its population at that time was about 500, which ranked it behind only Monticello (1,000), Wurtsboro (650) and Liberty (600) in the county.

The tannery was owned by E.A. Clark & Company, and it contained 182 square vats, consumed five thousand cords of bark annually, manufactured about fifty thousand sides of leather a year and employed about thirty-five men year-round, more during bark-peeling season.

Jeffersonville was linked to Monticello by a turnpike, and in 1887 was linked to Liberty via telegraph lines.

"The line is not only a great benefit to the O&W and the people along the new telegraph line, but it is a necessity as well," Manville Wakefield wrote in his 1970 book, *To The Mountains By Rail*.

Wakefield also revealed that a spot-check of hotel and saloon bills in 1897 revealed that in the community of five hundred, over three thousand kegs of beer were consumed. A good portion of this beer was served at the dining room of the Beck Hotel, which had forty-five rooms when opened by John Beck in 1882. By 1912, it had grown to accommodate between 150 and 200 guests. The establishment was empty on December 12 of that year when Wakefield noted that

> *Mr. Beck placed an oil lamp in the bathroom on the second floor to keep the water from freezing in the pipes. It is believed the oil lamp exploded; but in any event, Mr. Beck had just enough time to arouse his sister-in-law, Miss Christine Ruppert, and make an escape from the second floor. Two hose carts were brought to bear, but it wasn't until the water pumps in Bollenbach's grist mill were set in motion that the pressure increased enough to save adjoining buildings.*

The community was not so fortunate a few years later, when a major fire destroyed a good part of its business district.

In the early morning hours of May 10, 1918, fire broke out in the kitchen of the Eagle Hotel and quickly spread to the Goubelman Building and then the Lichtig Building on the south, and to Eddie Homer's home and café and Beck's Department Store on the north. Becker's Drug Store was also destroyed, as was the Holmes & Martin automobile dealership and its inventory of six cars.

Jeffersonville was quick to rebuild, and the community continued to grow, becoming an incorporated village in 1924.

PHILLIPSPORT

Even those with more than a casual interest in Sullivan County history are often surprised to find that the hamlet of Phillipsport was once among the most bustling communities and largest population centers in the area.

As its name suggests, Phillipsport grew up around the D&H Canal, which opened for business in 1828. The canal company originally called it Lockport, for there were ten locks located within a mile or so of one another in this area, but it soon became known as Phillipsport in recognition of James Phillips, who was the principal businessman there at the time, and not, as some sources indicate, for Philip Hone, canal company president and mayor of New York City.

"During the summer of 1828, the first season of full operation, James W. Phillips & Co. had already established a freight line on the canal," wrote Larry Lowenthal in his 1997 history of the D&H, *From the Coalfields to the Hudson*. "With the boats *Liberty*, *Gold Hunter*, and *Royal Oak*, Phillips planned to make at least three trips a week between Phillipsport and the Hudson."

By 1872, the community had grown to encompass a church, a school, a hotel, two stores, three groceries, a wagon shop, two blacksmith shops, three shoe shops, a millinery shop, two dressmaking establishments, a sawmill and three boatyards. Its population of 400 ranked it behind only Monticello (1,000), Wurtsboro (650), Liberty (600), Jeffersonville (500) and Douglass (450) in the county.

By that time, the community had the good fortune of also serving as a stop on the New York & Oswego Midland Railroad (later the O&W), which added to its importance. Industry was served by a substantial amount of water power in the vicinity. Quinlan wrote in his *History of Sullivan County* that "a handsome stream of water comes foaming down successive falls, which are equally pleasing to the utilitarian and the lover of the picturesque. There is sufficient hydraulic power here for extensive manufacturing purposes."

No industry was quite so important to the prosperity of Phillipsport as boat building, which set the hamlet apart from many others along the 108-mile route of the canal. As Manville B. Wakefield noted in his 1965 book on the canal, *Coal Boats to Tidewater*, "Phillipsport was a bustling boat building canal town."

The D&H Canal just outside Phillipsport.

Wakefield further noted that "the leading boat builders at Phillipsport were Wesley B. Snyder, who had his works at Lock #45, Charles Medler, and Russell & Baker, who operated a dry dock and boat building yard. At Lock #42, James A. Caldwell operated a boat building yard, while his brother Stephen built and repaired boats at Lock #40."

These boat builders were particularly happy whenever the canal was enlarged, thus enabling the use of larger boats, when orders would come in for new fleets.

Between 1842 and 1844, Wakefield wrote, "about 100 boats of 50 tons capacity were built for the anticipated enlargement, long before they could be adequately absorbed into normal canal operations."

Phillipsport's fortunes sagged dramatically upon the closing of the canal operation in 1898. Today, the importance of the canal to the economy of the community, as well as the county in general, is commemorated by the linear canal park being developed there.

Despite its location on the railroad line, Phillipsport never developed as the kind of tourist destination that nearby Summitville and Spring Glen did. For example, the 1940 vacation guide for the O&W Railway, which succeeded the Midland, had but one listing for the hamlet, while several were featured for each of its aforementioned neighbors.

"Phillipsport is a pleasant little village," the guide noted. "Several hotels and private families in the vicinity receive summer boarders. Excellent hunting and fishing in season."

The only establishment advertising in the guide that year was Mahlon Budd's Pleasant Valley Farm House, which accommodated thirty boarders and offered fresh vegetables, eggs and milk. It also featured a large piazza and daily mail service. The Budd family had been among the earliest settlers in the area.

Spenser's Bungalow Colony, located just a short distance from the old canal bed, was a popular spot a few years later. One former guest, Morty Frankel, remembered in Myrna Katz Frommer and Harvey Frommer's 1991 *It Happened in the Catskills* that Spenser's "was run by Gentiles, but all the guests were Jewish. Back of the pastures, beyond the farms, were wide barge canals with cement walls. There was no water in them by the time we were there, and we kids would play all kinds of games in them."

Guests at Spenser's loved to go berry picking, which a half century earlier had been so popular in the area that the O&W had run excursions just for the pickers. But Frankel recalled that this could prove a dangerous pastime:

> *The grown-ups would warn us, "don't get caught by the mountain people up there." Sure enough, just like in the picture, Deliverance, regular mountain people lived up there. They all seemed so big, with long full beards, dressed in overalls. We'd be picking berries or exploring, and sometimes they'd come out. We'd run all the way back down the mountain till we got back to Spenser's place.*

RESORTS
AND RECREATION

THE COLUMBIA

Locals once called it "Knapp's Folly." Commanding a lofty perch high on the hill just outside Hurleyville, it was the oldest continuously operating resort in the county when it finally closed. It was the Columbia Hotel.

The Columbia was founded by John Harms Knapp and his second wife, Mary C. Brophy Knapp, in 1891. John Knapp, an 1874 graduate of Eastman Business College, had previously operated a general store in Hurleyville, while his wife had an extensive hotel background, her family having operated the popular Mountain View House (also occasionally known as Brophy's Mad House) in Hurleyville. That resort, particularly popular with New York City policemen and firemen, burned in 1910.

The Columbia Farms, as it was originally known, was constructed strategically on the summit, with 250 feet of verandas providing an incredible panorama for guests. The hill was nearly barren of trees in those days, but Knapp planted a number of maples around the property to enhance the natural beauty. Like so many of the early Sullivan County hotels, the Columbia included a working farm, which housed a dairy complete with Guernsey cows. Guests were treated to milk, butter, eggs, poultry, maple sugar and vegetables, all grown or produced on the premises. The hotel operation was small at first, but grew steadily. By 1898, the Columbia was able to accommodate 150 guests. Many of the guests at that time would check in for six or eight weeks at a time and often brought their own staff of maids and governesses with them.

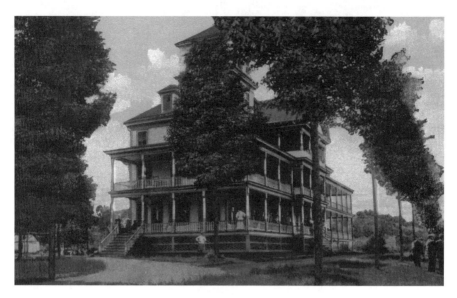

The main building at the Columbia Farms in Hurleyville, circa 1910.

A 1905 brochure indicated that the hotel charged from ten to sixteen dollars per week for single persons, from eighteen to twenty-four dollars for two persons and from two to three dollars a day for transients. The brochure advised that free transportation was provided from the O&W Railway's Luzon station in Hurleyville, and that "positively no consumptives" would be accommodated.

The brochure's description continued:

> *Wide piazzas and balconies surround the main building. It is modern in style, comfortably furnished, and replete with every convenience calculated to enhance the comfort and pleasure of our guests.*
>
> *The public rooms are commodious, the sleeping apartments large, light, and well furnished. Connecting rooms and rooms en suite with private bath and toilet are also available. The building is heated with steam and lighted with gas. Hot and cold water, baths and lavatories and toilet rooms are on every floor. We have the best sanitary plumbing. Both water and ice are obtained from one of the largest and best springs in the country.*

John Harms Knapp suffered a stroke and died in 1912, from which time his wife ran the operation until her own passing in 1936. By that time, their son, Benjamin Knapp II, was ready to assume control. The hotel he inherited included a swimming pool erected in 1923—the first pool in the

county completely independent of any direct water supply, and a nine-hole golf course, opened in 1932.

Ben Knapp almost immediately began a major expansion, which included the construction of twelve additional rooms, all with private baths, and a large dance pavilion. Within a few years, he had added twelve more rooms with private baths and eventually constructed a new lobby, dining room, nightclub and a second golf course.

By the time Ben Knapp died in 1960, the hotel had added an additional thirty rooms. In 1963, the Columbia, at the time being run by Ben's three sons, John J., Ben III and William, joined the growing trend in the county to stay open all year. Around that same time, the hotel added another building with twenty-five rooms, as well as a ski hill.

The Columbia celebrated its Diamond Jubilee in the summer of 1966 with a number of special events and had big plans for the future.

Old carriages, similar to those that once met guests at the train station, were parked throughout the hotel grounds. Exhibitions of old furniture and photographs helped get guests in the spirit, as did the fact that hotel staff dressed in period garb. Waiters, for example, wore striped blazers and straw skimmers, bartenders sported red aprons and armbands and waitresses were decked out in peasant dresses.

The Columbia had one of county's first swimming pools. This is a later version.

That year, the hotel's weekly rates ranged from $87 to $126 for a full American plan, which included three meals a day. The Columbia could accommodate about 330 guests and featured an Olympic-sized swimming pool, two golf courses and tennis courts. The brothers who ran the facility promised to continue the traditional homey atmosphere of the hotel.

"We plan to make it a quaint old-fashioned looking resort with every modern facility," they told a local newspaper. There were plans for an indoor pool, additional suites, a new nightclub and more public space for conventions and meetings, but every attempt would be made, they noted, to avoid turning the place into "one of those modernistic, glass and steel structures which eliminate the personal touch so much a tradition of their 75-year old hotel."

But unbeknownst to the Knapps, as well as most of the other hotel owners in the county, the Golden Age had ended, and the resort industry was about to enter hard times. By 1969, the Columbia had closed and filed for bankruptcy protection. In September 1970, Ray Parker, president of the Concord Hotel, purchased the hotel property for $111,000. The purchase price did not include any private belongings, furniture or equipment.

The main hotel building was destroyed in a suspicious fire on Christmas Eve 1971. The flames were visible from Liberty, and the red glow in the sky could be seen from as far away as Livingston Manor.

THE END OF THE GOLDEN AGE

People are often incredulous when, in discussing the evolution of the Sullivan County resort industry, they are told that the so-called Golden Age of that industry ended in 1965.

"How could that be?" they ask, before adding emphatically, "I remember that many of the hotels continued to thrive well into the 1970s."

And yet most historians today agree that the Golden Age of Sullivan County's tourism industry, which began in earnest around 1940, did come to an end around 1965, and they cite a number of reasons for choosing that particular year.

A fire at the Prospect Inn in Parksville on August 11, 1965, resulted in the death of five people and caused a clamor to tighten up fire codes for local resorts, many of which could not afford to make the necessary improvements. Smaller resorts, which made up the bulk of Sullivan County's 538 hotels during that golden era, began to close down. Those that could make the necessary upgrades found themselves hopelessly in debt.

Many of these establishments had already invested capital they didn't have in trying to keep up with the larger hotels in the increasingly competitive Catskills tourism market. In fact, by 1966, this disturbing trend had become so obvious that it caught the attention of the *New York Times*.

Reporter Homer Bigart outlined the phenomenon in a September 5, 1966 article with a Loch Sheldrake dateline, entitled "Keeping Up With the Grossingers Strains Many Catskills Hotels."

Bigart used the occasion of the Labor Day weekend—traditionally one of the busiest of the year for Sullivan County resorts—to visit a number that had closed down or seemed on the verge of doing so.

"A singular hush, betrayed only by the occasional romping of crickets or the stomping of a stray hen on the greensward, fell this Labor Day weekend on the rococo precincts of the New Roxy Hotel," Bigart wrote. "Gone were the glamorous, fun-loving vacationing crowds of former seasons. A rancid smell of decaying food filtered down the carpeted corridors from the kitchen. An eerie silence ruled the lobby, mocking a notice forbidding card-playing and another that urged, 'Sign Up Now for Talent Night.'"

The New Roxy had closed in mid-August that summer, "the latest in a long list of casualties among the medium-sized hotels in the Catskills, hotels accommodating 200 to 700 guests," Bigart noted.

Buildings at Grossinger's in the 1950s.

The owners of the New Roxy had borrowed over $700,000 in an effort to draw vacationers to their resort.

"Trying to keep up with the prosperous giants like Grossinger's and the Concord, they have gone heavily into debt for Olympic swimming pools, indoors and outdoors, ornate lobbies and glittering nightclubs," he wrote.

Bigart quoted an unnamed South Fallsburg banker and lawyer who pointed out that "many of the smaller hotels are in trouble because they are obsolete" and could not afford to modernize to "meet today's more luxurious standards, like baths in every room." Also, he said, the lure of more glamorous places like Jamaica, Puerto Rico and Europe were attracting more and more of the traditional Sullivan County vacationer.

"The older generation that used to come here is dying out," he said, "and their children are a little bit bored with us by now."

Bigart reported that in Loch Sheldrake, where there had been forty-two hotels "ten years ago," there were only twelve. He visited the Loch Sheldrake Inn, Goldberg's and the Overlook, each of which had recently closed. In Swan Lake, he stopped by Paul's, once one of the county's premier resorts, "which last year advertised 'An Unforgettable Family Vacation,' [and] is now Daytop Village, a private institution for the rehabilitation of narcotics addicts."

The indoor pool at Grossinger's. The cost of constructing such amenities bankrupted many hotels.

Resorts and Recreation

Bigart also mentioned that larger resorts, such as the Waldemere in Livingston Manor and the Flagler in Fallsburg, had filed for bankruptcy protection. Abe Rosenthal, manager of the Waldemere, specifically blamed the hotel's financial problems on the "new fireproof building costing $2 million," built after a fire three years before had killed three guests.

Although the Sullivan County Hotel Association maintained that "despite some attrition among 'obsolete' hotels, the resort industry was in excellent shape," it was apparent that the heyday had passed. By 1968, for example, the *Times* reported that a number of smaller hotels, "unable to keep pace with the large establishments and their newer, plush accommodations," had begun taking in campers. One such hotel, Sokolow's Mount Vernon in Summitville, had torn down walls in some of its outer buildings in order to provide large recreation rooms for visitors to use on rainy days and had added roadways, electrical connections and plumbing hookups to campsites.

"If the plan at the Mount Vernon works out," Director of Parks and Recreation Joe Purcell was quoted as saying, "there is no doubt that owners of some of our smaller hotels will enter the camping business."

Evidence enough that the Golden Age had definitely come to an end.

Golf Courses

It is believed that Scottish-born George Ross Mackenzie, the multimillionaire executive of the Singer Sewing Machine Company, built the first golf course in Sullivan County around 1895 on the grounds of the Homestead, his magnificent estate in Glen Spey.

And beginning in the summer of 1897, when guests at Trout Valley Farm in Beaverkill played golf on a crude course fashioned from a sheep pasture, the sport has played a major role in the development of tourism here.

That initial Trout Valley Farm layout comprised just a few holes, and by the time it was upgraded to nine holes in 1901, there were already a number of other courses in the county. In fact, the Industrial Edition of the Sullivan County *Republican* newspaper, published in August 1899, contained advertisements for over one hundred hotels and boardinghouses, at least ten of which mentioned "golf grounds" on the premises.

An article in the June 1901 *New York Evening Post* noted that Sullivan County was home to three "good nine hole courses, one in the outskirts of Liberty, a course at the edge of White Lake, and a third at Kiamesha."

The Liberty course was first known simply as the Country Club, but by 1903 it had become part of the Wawonda, then the largest of the area's

Trout Valley Farm became home to the county's first public golf course in 1897.

many hotels. The White Lake course was shared by a number of hotels, including the Mansion House and the Prospect House. The Bonnie Golf Club in Kiamesha, which unabashedly advertised in the *New York Times* that year as the "finest golf links in Sullivan County," was also shared by a number of hotels, including the largest on the lake, C.M. Bartlett's Kiamesha Lake House.

In 1903, the *New York Times* reported that the Monticello Country Club had hired golf professional James Kenehan to manage its links. This course was still operating as the Monticello Country Club in 1908 and may have evolved into the Pine Knoll Country Club on Port Jervis Road, which was popular in the 1930s.

The Lakewood Farms Inn near Roscoe once claimed to have the county's second-oldest course, designed by Scotsman Thomas B. Lindsay and constructed sometime around the turn of the century. There was also an early course at DeBruce. The Loomis Sanitarium once had its own private course for those patients healthy enough to play.

It wasn't unusual for these early courses to run through cow and sheep pastures, and more than one course, including Trout Valley Farm, utilized sheep to keep the cost of mowing the fairways to a minimum. The hotel spent about five dollars a month to keep the greens mowed.

The Tennanah Lake House began advertising golf around 1910, and in the early 1920s, the Twin Village public course between Roscoe and

Early golf at the Lakewood Inn, which long claimed the county's second-oldest course. This is debatable.

Rockland began operation. The Sullivan County Golf and Country Club opened in 1925; the Flagler Hotel and Country Club, then the county's premier resort, constructed its course around the same time; Columbia Farms in Hurleyville opened its first course in 1930; and Grossinger's first golf course was completed in time for the 1932 hotel season.

The nine-hole course at the Laurels in Sackett Lake may date to 1940, when the hotel purchased the 207 acres that had previously been the estate of the recently deceased George A. Drake along with Drake's mansion on the lake. Young's Gap Hotel in Parksville opened a nine-hole layout in 1943. The Concord added the eighteen-hole "International" course to its nine-hole "Challenger" layout in 1948.

By 1953, the *New York Times* was reporting that among the "538 hotels, 50,000 bungalows, and 1,000 rooming houses" in Sullivan County were nestled eighteen golf courses. To put this into perspective, the *Times* noted that "the other 3,069 counties in the United States have to skimp along on about 5,000 between them."

In June 1959, the *New York Times* reported on a number of developments on the golfing front, including the construction of two new courses and the expansion of a third.

"The newest of the area's thirteen courses is a pretty nine hole layout at Kutsher's Country Club, just outside [Monticello]," reporter Michael Strauss wrote. "The management of the nearby Morningside has under construction an eighteen hole course, while the Tennanah Lake House at Livingston Manor [*sic*] added a second nine holes to its sky-top course last

105

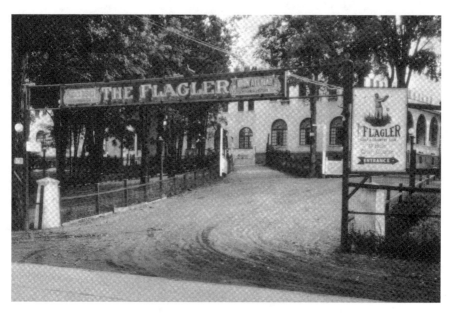

The main entrance to the Flagler in Fallsburg, with the sign (right) directing guests to the nine-hole golf course, which was built in the 1920s.

The nine-hole golf course at the Laurels, for a time the largest hotel in Sullivan County.

season. In addition, the town of Fallsburg is committed to build an eighteen hole course about a mile and a half south of South Fallsburg."

The course Strauss referred to as being built by the Morningside later became the Lochmor course, currently operated by the Town of Fallsburg. Not only does Lochmor combine the names of Loch Shedrake and Morningside, but it also commemorates a famous golf course of the same name near Detroit, Michigan.

In a Monticello-datelined article on August 30, 1959, Strauss reported in the *Times* that

> *at the present time there are fifteen golf courses in Sullivan County well sprinkled through the area. Eight of them are within six miles of this village, the county seat. Here can be found courses that are hilly, flat, well-trapped, beautifully landscaped, and well manicured. Nine hole courses are situated in Roscoe, Liberty, Kiamesha Lake, Hurleyville, Monticello, Sackett Lake, South Fallsburg, Highland Lake, and Livingston Manor. Many of these are new. For the less athletic, pitch and putt layouts are to be found at Hurleyville and Greenfield Park.*

Strauss also reported that the "Town of Fallsburg is now enthusiastically supporting the construction of an eighteen hole course to be known as Tarry Brae, so named because the course will be dotted with lakes and ponds in an arrangement similar to courses found in Scotland."

By the summer of 1961, the *Times* was reporting that the number of golf courses in Sullivan and the Ellenville area of Ulster County had grown to twenty. Tarry Brae, the municipal course in South Fallsburg, had just opened, and the Tennanah Lake nine-hole course had just been expanded to eighteen holes. Kutsher's, the paper noted, had begun expanding its nine-hole layout to eighteen and expected to have the extended course open the following season.

"Sullivan County, which has been sports-minded ever since the days when croquet was the popular pastime more than fifty years ago, is bidding to become one of the golf capitals of the world," the *Times* reported. "The modest croquet lawn has made way for a collection of golf courses that is said to make the southern Catskills one of the busiest rural links areas in the world."

The big news that year was the construction of the Concord's newest innovation, the 7,445-yard, eighteen-hole course soon to be named "the Monster." The paper predicted the course would be completed by the following year. The new course would join the nine-hole "Challenger"

The Monster Golf Course at the Concord measured over 7,600 yards.

and the well-established "International," increasing the number of holes available at the county's largest resort to forty-five.

"There is little doubt that this new layout will be one of the most testing courses in America," the *Times* claimed. "There will be plenty of traps and water holes, and even professionals are expected to find it difficult to match the par of 72. The longest hole will be 650 yards, and the shortest will be 165 yards."

The *Times* predicted that the county would soon add even more golf facilities, and attract even more people from the metropolitan area.

Yet it was not to be. Before the end of the decade, the county's Golden Age would have come to an end, and new golf courses were few and far between. Most of those 538 hotels had closed by 1970, and so had many of the golf courses, which had simply become too expensive to maintain.

Skiing

Long before the opening of Davos in Woodridge ushered in a new era in skiing in Sullivan County, before Grossinger's and the Concord pioneered snowmaking techniques to service their rudimentary ski hills and even before the five Miller brothers operated Christmas Hills in Livingston Manor, skiing made its local debut at Walnut Mountain in Liberty.

Sometime in the 1930s, a group of Liberty residents created a skiing facility at the site of the old Walnut Mountain House just outside the village. The ski area operated for a number of years, closing sometime during World War II. It was crude by modern standards, and, devoid of any snowmaking equipment, operated at the mercy of Mother Nature, but it did feature a rope tow powered by the engine from an old Model T Ford.

Walnut Mountain Ski Area in Liberty, the county's first.

Other than that, not a lot is known about what was undoubtedly the area's first public ski facility. By far the best documentation of the operation is found in the popular CD-ROM entitled *Liberty, NY: Memories* put out by Between the Lakes Group of Salisbury, Connecticut. The company is owned by former Liberty resident Geoff Brown and has published a number of CD-ROMs pertaining to Sullivan County history.

The section of the CD-ROM devoted to the Walnut Mountain Ski Area contains several photos of the ski operation and a brief text, penned by Brown himself:

> *In the 1930s, a loose confederation of Liberty residents—and a few from nearby communities—decided to create a ski area. Walnut Mountain, since the Walnut Mountain House had burned, and since the slopes were both fairly steep and clear of trees, was perceived to be an ideal site. In that age of wooden skis, without metal edges, with "beartrap" bindings that locked the boot securely to the ski regardless of twisting, falling, or any other catastrophe, very likely the slopes of Walnut were an appropriate athletic challenge.*

Brown noted that the ski area at Walnut had a rather short life, not just because of the lack of skiers during the war years, but because of the lack of snow during many winters:

> *The ski area, never a commercial success because of the Depression (if anyone ever intended it to be more than a recreational facility with no profit motive at all), finally ceased operation during World War II, as many of the younger people who might have skied there were in Europe or the Pacific instead. Perhaps even more pivotal in the decline of the Walnut Mountain Ski Area than the Depression and the Second World War was nature: insufficient dependable snow. Compensating somewhat was that at the time downhill speeds were not sufficient to make a little grass showing through the snow, or even a bush, into a lethal obstacle. Unacceptable conditions at a ski area today; but routine in the numbered days of the Walnut Mountain Ski Area!*

Unlike the county's later ski facilities, which featured fancy lodges and chalets where tired skiers could warm up with a hot drink and watch the action on the adjacent hills, Walnut Mountain offered just a boulder on which to rest. Still, the lack of a warm place to rest didn't seem to bother most of the patrons.

A skier takes a fall on Walnut Mountain.

"Since Walnut Mountain House had burned to the ground some years previously, there were no structures available for warming, refreshment, *gemuchtlicht*, etc., atop Walnut," Brown wrote. "Instead, skiers brought their refreshments in knapsacks and warmed in the sun atop [a] boulder."

Brown noted that old photographs reveal that dress on the hill was rather casual—bomber jackets and baggy pants were common among the men, as were parkas and hunting shirts. Women were similarly dressed.

Sometime after the close of the Walnut Mountain facility and the opening of the Christmas Hills site in Livingston Manor, the winter sports scene began to change dramatically at Sullivan County's many hotels. While some pioneering hotels, including Grossinger's and the Flagler, were offering toboggan runs and ice skating rinks at least two decades earlier, it wasn't until the 1950s that skiing became popular at area hotels.

The largest hotels—the Concord and Grossinger's—paved the way, and other facilities soon followed. By the winter of 1958, there were four ski

The first large-scale commercial snowmaking operation was at Grossinger's in 1952. This rare photo features a second-generation nozzle, circa 1956. *Courtesy of the New England Ski Museum.*

Skiers at the Concord ski chalet.

areas operating in the county, and night skiing had also become popular. And when Mother Nature didn't cooperate, snowmaking machines were cranked up to fill in.

"Although the lower Catskills, specifically in Sullivan County, do not have a great wealth of skiable snow under normal conditions, this teeming resort area has earned the title of the artificial snow capital of New York State," Michael Strauss wrote in the *New York Times* on December 7 of that year.

The Concord claimed the distinction of being the first place to make its own snow, and later even livened things up by providing the artificial powder in different colors. By 1958, the hotel was operating an Austrian-manufactured T-bar lift capable of transporting 460 skiers per hour. The lift was 1,245 feet long and served the hotel's most challenging hill, with a vertical drop of 139 feet.

The Concord also offered two rope tows and its original platter tow, and spruced up its chalet that winter.

"The ski chalet has just been enlarged," Strauss noted. "The addition consists of a wing, forty-eight by twenty-six feet that faces the slopes and is encased in thermo glass so that the tired skier may sit indoors and bask in the sun."

Grossinger's also offered artificial snowmaking for those days when the natural stuff just didn't measure up. Not to be outdone by its larger rival in Kiamesha Lake, the Liberty resort began planning the purchase of an Austrian-made T-bar.

And just to the north of Grossinger's, another hotel was attempting to capitalize on the skiing phenomenon.

"One other hotel which may expand its skiing facilities is the Young's Gap at Liberty," Strauss reported. "A rope tow services the area, which is actually an interesting slope on the resort's golf course."

The new kid on the block, though, was the Holiday Mountain Ski Area outside Monticello, founded a year earlier. Holiday featured a Pomalift and snowmaking machines, and provided skiing seven days a week and on Friday nights.

"At Holiday Mountain several of the slopes are now lighted," Strauss wrote. "Patrons can come immediately after business on Friday and stay through Sunday afternoon. Route 17 from the Harriman interchange on the Thruway to Monticello is now complete and may be traversed without a traffic light."

The Bridgeville ski area, the brainchild of Monticello businessmen Don Hammond and Manny Bogner, had actually first begun operation in November 1949 with three electric tows, open slopes, expert trails, a Swiss

Ski School with instructors, a warming hut with refreshments and a ski shop, but it was abandoned after a few years because of a lack of snow.

The new Holiday had been completely revamped. Billing itself as the closest ski area of its kind to New York City, it had a vertical rise of 230 feet, starting from a base elevation of 1,600 feet above sea level.

"It will be no layout to captivate the imagination of experts accustomed to tearing down Stowe's Nosedive or Mount Greylock's Thunderbolt, but it will more than suffice for the run-of-the-mill sports lover who wants to test his legs as well as enjoy the sport with a minimum risk of injury," predicted the *New York Times* on December 8, 1957.

The hill featured two rope tows, and a nine-hundred-foot Pomalift shipped in from France and installed just in time for the opening. This state-of-the-art lift could handle nine hundred skiers per hour. The ski area's trails and slopes all had holiday-related names, including "Easter Parade," "Birthday Schuss" and "Christmas Bowl." The refurbished development also offered skiers a new ski lodge and chalet, a restaurant and a ski shop where one hundred pairs of skis and fifty pairs of Swiss ski boots were available for rent.

Holiday Mountain continued to improve its operation over the next several years and managed to survive the opening of the larger and better-equipped Davos in Woodridge in 1959, as well as the advent and expansion of other ski hills, including the nearby Columbia and the Pines, which, in 1965, became the first hotel to feature a chairlift.

One of the innovations the hill instituted beginning in 1963 was a concerted effort to attract young skiers. That winter, ski school director Pete Martini began offering clinics just for kids each weekend morning.

"The response from youngsters—the program is aimed at boys and girls from 4 years old to 18—is in keeping with teenagers' enthusiasm from coast to coast," the *Times* reported on December 19, 1963, noting that Holiday had already sold three hundred season tickets to youngsters.

Holiday played a big part in the Monticello Jaycees's inaugural Winter Carnival in January 1966, providing the venue for slalom races, shovel races, fireworks and a Friday night ski party. The following year, the hill opened its gently sloping Lollipop Ridge area for the really young skier.

In the fall of 1969, the Town of Thompson added 105 additional acres to the facility, nearly doubling its skiing area. The town also added a second chairlift that year, as well as another Pomalift.

"As a result, when the season opens, Holiday Mountain will be able to handle about 5,000 skiers an hour on a J-bar, and three rope tows, plus the two double chairs and the pair of Poma-lifts," the *Times* reported on October

26, 1969. "The expanded facilities at Holiday Mountain are certain to prove helpful to nearby resort hotels."

When Holiday opened for the season later that year, its problem was not too little snow, which was so often the case, but too much. The ski area's manager, Vic Gordon, had spent weeks overseeing an around-the-clock snowmaking operation that had resulted in over fifteen inches of man-made cover virtually everywhere, only to see Mother Nature decide not to be outdone.

Over a foot of snow fell on the ski area just before Christmas, and then eighteen inches more. By the day after Christmas, yet another storm had dumped several more inches on the slopes, and the hill couldn't even open because of thirty-five-mile-per-hour winds. By December 27, all five lifts were in operation, but skiers were scarce: only a few hundred showed up instead of the 1,500 that were expected. It was a severe financial blow.

By 1960, Holiday was facing plenty of competition. There were a dozen Sullivan County hotels open all year, and the Laurels and the Flagler were open for the Christmas and New Year's holidays, as well as Lincoln's and Washington's Birthdays.

The *Times* reported on December 4, 1960:

> *This year's winter activity is reminiscent of that of three and four decades ago, when a number of Sullivan County hotels endeavored to remain open on a year-round basis, hoping that such inducements as rides in horse-drawn sleighs and ice skating would entice sports-minded visitors away from their urban fireplaces. The advent of superhighways, however, marked the disappearance of the sleigh, and fickle winter weather cut the skating to a minimum. This year, however, ski resort operators in the southern Catskills have left nothing to chance. Four of the leading ski centers in Sullivan County are equipped with machines for making artificial snow.*

One of those was Davos, the largest of the Sullivan County ski areas and the first to feature a chairlift.

"Davos is named after the Swiss ski resort and now has three double chairlifts, a T-bar, and a rope tow," the *Times* noted. "Its slopes are not long, for the most part, but at least two of them are steep enough to make the skier of intermediate skill take careful stock of what lies below before shoving off."

By 1966, the *Times* was reporting that there

> *are now about 40 slopes and some two dozen trails in the southern Catskills, [and] more than 40 lifts of all descriptions—chairs, T-bars,*

Pomalifts, and even rope tows—are ready to provide uphill transportation for patrons.

Among the area hotels offering skiing, ice-skating, and indoor swimming on or close to the main grounds are the Concord, Gibber's, Grossinger's, Laurels, the Raleigh, the Pines, Kutsher's, Homowack Lodge, the Granit, the Nevele, the Fallsview, and Young's Gap. Other resorts that aim for the skiing crowd in particular include Avon Lodge, the Columbia Hotel, Davos, and Mount Cathalia.

Trout Fishing in Sullivan County

Alan Barrish is not himself a fisherman, but he is quick to point out the significant role the sport has played in the economic development of Sullivan County. And he was one of the first to discuss the role that several well-known writers and artists of the nineteenth century played in spreading the word that the trout streams of this area were among the most abundant in the country.

Several years ago, for example, Barrish, who is the director of the Crawford Public Library in Monticello, discovered the importance of the painter Henry Inman in promoting the county as a trout fishing mecca and began assembling information about him.

Inman was certainly not the first man ever to enjoy the quiet pursuit of trout in Sullivan County's bountiful waters, but he surely provided one of the most enduring tributes to the popular pastime.

Although rarely seen today (the original was rediscovered in 1983 and hangs in the Munson-Williams-Proctor Institute museum in Utica), Inman's 1841 oil painting *Trout Fishing in Sullivan County* was, in its time, the most renowned landscape work of a celebrated American artist.

Inman's work was no doubt a labor of love, as it was common knowledge among the literati of the day that he was passionate about his fishing.

"Henry Inman made regular pilgrimages to the distant wilds of Sullivan County and was one of the first to explore the exceptional trout fishing found along the Beaverkill, Willowemoc, and Callicoon Creeks," wrote Ed Van Put in his recently published book, *Trout Fishing in the Catskills*. "His devotion to trout fishing was well known to the New Yorkers of his day."

While trout fishing in this area dates back at least to the days of the Lenape, they preferred to fish for shad because of its many uses and employed a rather unique method of fishing for trout, which utilized the bark of the walnut tree to form a mixture that immobilized the fish.

Henry Inman's *Trout Fishing in Sullivan County* helped spread the word about the recreational opportunities in the area. *Courtesy of Munson-Williams-Proctor Institute, Utica, New York.*

European visitors to Sullivan County waters who began arriving with the dawn of the nineteenth century used more conventional means of fishing. In his earlier work, *The Beaverkill*, Van Put wrote that by the time *American Turf Register and Sporting Magazine*, "the first of its kind in the United States, made its debut in 1829, the Beaverkill was already well known to trout fishermen."

The late historian, Alf Evers, writing in his 1972 book, *The Catskills: From Wilderness to Woodstock*, recorded that it was in 1832 that "Charles Fenno Hoffman, who was then beginning a brief but notable career as poet, editor, and novelist, told of watching a six-pound trout being taken from Sullivan County's White Lake."

It was just a few years later that the young portrait artist Inman began familiarizing himself with the sporting opportunities this area offered.

Inman was born at Utica on October 28, 1801, and moved to New York City with his family in 1812. He received an appointment to the U.S. Military

Academy at West Point, but decided to pursue an art career instead, signing on for a seven-year stint as an apprentice to the portrait painter John Wesley Jarvis.

By 1823, Inman had set up his own studio in New York, where he began painting portraits, miniatures and genre pieces. The *Dictionary of American Biography* noted that "many eminent sitters came to him. Few American portraitists since Stuart have to their credit a more imposing list of distinguished patrons."

But Inman never lost his love of field and stream and his passion for fishing soon spilled over to his work. Many painters had been attracted to Catskill scenes by the success of Thomas Cole, and Evers noted that "landscape painter Asher B. Durand was painting and fishing from bases in local inns and farmhouses by the 1840s, and he was often accompanied by students who might acquire painting and fishing skills simultaneously."

So when portrait painting commissions became fewer and farther between as photography was developed, Inman, too, turned to landscape art.

"No painter-fisherman was more enthusiastic about the Catskills than Henry Inman, the fashionable portrait painter who delighted in working on Sullivan County fishing scenes," Evers wrote. "Upon Inman's death in 1846 it was written that 'in trout fishing especially he excelled...A more ardent, accomplished or delightful disciple old Izaak Walton never had. In throwing a fly or spinning a mirror, he had few equals.'"

Although, according to William H. Gerdts in *The Art of Henry Inman* (1987), "Inman never aspired to the sublimity of landscape that attracted his colleague Thomas Cole, nor did he find in the theme great spiritual revelation," his love for the scenic beauty and tranquility that went along with fishing was evident in his work about it.

In *Trout Fishing in the Catskills,* Van Put summed up the importance of Inman's work—and the writings of his contemporaries—to those attempting to reconstruct the development of the sport here:

> *It is difficult to imagine what trout fishing was like for those anglers who first cast their lines into the lakes, ponds, and streams of the Catskills, before trout populations were depleted by overfishing or altered by the introduction of domestic fish or a competitive species. Documented accounts are rare, and when they are found, they usually reveal a fishery dramatically different from today.*

THE WAWONDA

Talk to people around Sullivan County these days, and many will express fond memories for the hundreds of hotels that once populated the region. Nostalgia for the heyday of the resorts is commonplace, and folks are quick to recall the Concord and Grossinger's, the Browns and the Pines, Young's Gap and the Stevensville, the Edgewood and the Waldemere.

But there were hundreds of other great hotels from Sullivan's past that have long since been forgotten. The mention of their names most often brings nothing more than a blank stare from even those with an active interest in the county's history. These are places like the Swannanoa, Ye Lancashire Inn, the Ferndale Villa, the White Lake Mansion House and, perhaps the greatest of them all, the Hotel Wawonda.

These are the hotels—built largely between 1845 and 1890, and operating, for the most part, until about 1915—of Sullivan County's Silver Age. Just a few of the structures survive today, and they are fading fast. It is a part of the county's history that is rapidly fading away.

Many of these hotels were magnificent examples of Victorian architecture—ornate wooden framed structures, with steeply pitched roofs, lots of dormers, and wide, expansive verandas. It's an architectural style that was abandoned shortly after the turn of the century and which survives here in just a handful of private homes and a few remaining Silver Age hotels.

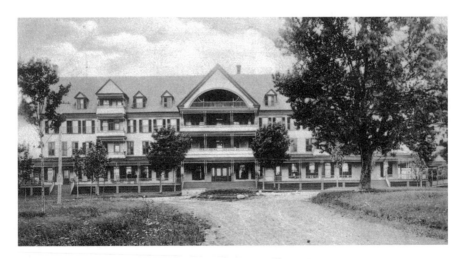

The Wawonda, the largest of the county's Silver Age hotels.

The Wawonda was the largest structure in Sullivan County during its existence, built by entrepreneurs J.C. Young, U.S. Messiter and Warren L. Scott in 1891. The hotel initially had three hundred rooms, spread over four stories measuring 42 feet by 180 feet, with a 40-foot by 135-foot wing. It featured 650 linear feet of porch, eight large public room fireplaces, a billiard room, a bowling alley, a telegraph office and a one-mile-long, 20-foot-wide bicycle path.

The *New York Times*, in its June 8, 1902 edition, called the Wawonda "one of the best equipped hotels" in the mountains.

"The house is located on a point 2,000 feet above the sea, contains 150 large sleeping rooms, and from all the many windows there are fine views of the scenic panorama spread about," the paper noted. "An orchestra plays morning and evening, and tennis, croquet, bowling, billiards, etc., are provided for the sport loving."

In a story about Sullivan County resorts in its July 12, 1903 edition, the *Times* reported that

> the Wawonda is picturesquely situated on one of the most commanding sites in Liberty; this popular hotel is already crowded with guests for the season. The Golf Club is located on the hotel grounds, and every day devotees of this popular outdoor pastime may be seen on the links playing their favorite game. Every evening in the hotel parlors there are musicales, card parties, and dances.

Like most of the resorts of the era, the Wawonda thrived for a number of years, despite the stigma the nearby Loomis Sanatorium cast upon Liberty when it opened in 1896. Throughout the early years of the twentieth century, the Wawonda's rooms were full virtually every weekend. The hotel dining room served an average of two hundred dinners on a Sunday night. But the hotel's relatively short life came to an end on June 9, 1914, when it was destroyed by fire. It was the beginning of the end for the Silver Age.

In fact, the last few years were not tranquil ones for the Wawonda. Manville B. Wakefield wrote in *To the Mountains by Rail* that fire first struck in 1907:

> The considerable investment made by the builders in fire equipment paid off in September of 1907 when a fire in the reception hall fireplace ignited the roof. A house hose rushed to the spot on the roof—a fire ax—a hole—and the fire was dispatched. Well that it was, since the fire alarm in Liberty, the Baptist Church bell, as well as other village church bells, were already ringing for Sunday morning services.

On June 4, 1910, the Wawonda was sold at public auction. The Liberty Register [newspaper] *reported that originally "it was patronized by a very wealthy class of people coming mostly from New York City, Philadelphia, and Washington. Frequently the guests brought their entire families, carriages, and stewards, staying for the whole season. A year or two after the Loomis Sanatorium was established, the number of wealthy people who had before visited the hotel began to stop coming."*

In 1911, the management was taken over by J.F. Warner at a time when patronage had dipped to a new low. On Tuesday, June 9, 1914, between 1 and 3 o'clock a.m. a fire of unknown origin leveled the sprawling hotel, sending flames 300 feet into the night sky, lighting up the surrounding hills with an eerie glow that revealed hundreds of huddled spectators.

Sadly, it was the same fate that befell most of the Silver Age resorts. The Swannanoa burned in 1912, and Ye Lancashire Inn in 1920. Those hotels that did survive were transformed over the years into a different sort of resort—the clean lines, Palladium windows and stucco finish of the Catskill Mission style—obscuring the original structures from all but the most discerning eye.

YOUNG'S GAP

It was one of the first hotels in Sullivan County to become electrified, the first to be built with steel and brick, the first with an elevator, the first with an indoor pool and one of the first with an indoor skating rink. It was also the first of the large hotels to go out of business, effectively signaling an end to the area's Golden Age.

It was the Young's Gap Hotel in Parksville.

The name of the hotel came from the peculiar geographical entity of the same name, which was notorious for its weather. The gap in the mountains between Liberty and Parksville often created blizzards where snowfall accumulations seemed to far exceed those registered elsewhere. The gap was located at the highest elevation—nearly 1,800 feet—on the entire route of the O&W Railway. The Young's Gap Hotel evolved out of a farmhouse originally built by William Young and later operated by Josephine Armstrong.

Business partners Louis Gelberg and Joseph Holder first came to Liberty in 1915 and purchased a nineteen-room house to entertain boarders. Finding it difficult to attract Jewish vacationers to the village, they sold the house in Liberty and, in 1922, purchased the farmhouse from Mrs. Armstrong. By

The Young's Gap Hotel was one of the most innovative in the county. Its closing was a signal that the Golden Age had ended.

1923, they were advertising in the O&W Railway's *Summer Homes* publication as the Young's Gap Hotel.

The partners were dynamic and innovative. They contracted with the Liberty Light & Power Company to electrify the hotel, while many other facilities were still relying on candles and kerosene lamps. They built a large concrete swimming pool, one of the first in the mountains, and constructed a golf course.

By 1928, they had built a new four-story main building of light-faced brick. Besides a large number of sleeping rooms, sufficient to accommodate four hundred guests, it housed a barbershop, tailor shop, ballroom, gymnasium, indoor pool and sun parlor. The incorporation of the shops into the hotel was an innovative feature that later evolved into the "fortress hotel" concept by which many of the large hotels offered their guests every imaginable amenity—from sundry shops to hair salons, boutiques and gas stations.

By 1930, Young's Gap could accommodate 600 guests, and was by far the largest of forty Parksville hotels, fifteen of which were open all year, including Klein's Hillside (accommodating 225), the Breezy Hill House (200), the New Mountain House (150), the Fiddle House (125) and the New Brighton (100).

Like most of the hotels in the area during that era, the Young's Gap featured a large social staff, populated by talented and ambitious entertainers. Merrill Miller, known to his co-workers as "Moishe," worked there in 1938. He became a veteran of the Borscht Belt, moving on to the Nevele, among others, and used his summer income to pay for voice lessons, eventually emerging as the opera star Robert Merrill.

"Ma Holder ran the place like a tyrant," he told Myrna Katz Frommer and Harvey Frommer for their book, *It Happened in the Catskills*. "She booked everyone, staged all the acts. I not only sang, I did comedy, performed as a straight man, danced in the finale. During the week it was suit and tie, but on weekends it was black tie. On Saturday nights I would do the big aria from 'The Barber of Seville.' It always stopped the show."

Renowned harmonica player Alan "Blackie" Schackner was another Young's Gap employee.

"I was the novelty act," he recalled in the Frommers' book. "My salary for the season was $200 plus room and board with double portions. My job was to play the harmonica on show nights and do some acting when needed. I also had to take care of the swimming pool and dance with the guests."

Artie Lewis and Peggy Ames, well-known vaudeville performers in their day, also worked at Young's Gap.

In 1949, the hotel was the setting for the film *Catskill Honeymoon*, which was directed by Josef Berne and filmed on location on the hotel grounds throughout the summer.

The film told the story of a Catskills hotel putting together a special celebration for the golden wedding anniversary of longtime guests. As part of the celebration, the hotel stages an old-time show, with singers, dancers and comedians. The Young's Gap's facilities, including the golf course, tennis courts, calisthenics classes and sunbathers, all play a major role in the picture, which ends with a grand salute to the new state of Israel.

That summer might well have marked the zenith of the Young's Gap's existence. Despite all of its early innovations, and facilities that rivaled any of its Sullivan County competitors, the hotel had begun a downward spiral as the 1950s drew to a close. By 1967, the Golden Age having ended and the area's resort industry entering into a new period of transition, the Young's Gap Hotel had closed its doors for good.

ABOUT THE AUTHOR

John Conway was born and raised in Sullivan County, educated at Georgia Institute of Technology in Atlanta, Georgia, and has been in the vanguard of the movement to chronicle and preserve local history for more than twenty years.

He has been the Sullivan County historian since 1993 and an adjunct professor at Sullivan County Community College since 2000.

He has written "Retrospect," a weekly column on local history, since 1987. He was a contributor for the latest edition (2006) of the *Encyclopedia of New York State* and has authored four previous books, three on Sullivan County history. He is regularly asked to provide a historical context for Sullivan County news events by the *New York Times*, Associated Press, Regional News Network and Fox News, among others. He has appeared on the Fox television series *Million Dollar Mysteries*, discussing the lost Catskills treasure of Prohibition-era gangster Dutch Schultz, and on the BBC television documentary *Stand Up America*, discussing the impact of the Borscht Belt on American comedy.

He has lectured on Sullivan County history throughout New York and Pennsylvania, including at the New York State Museum in Albany. He has received a number of awards, including a New York State Broadcaster's Association first-place award for best public affairs program for *A Look Back*, a series of historical vignettes he wrote, produced and voiced for WVOS radio in 1995. He was selected for the Sullivan County Historical Society's prestigious History Preserver Award in 2002, has won several merit awards from the Upper Delaware Heritage Alliance and was honored with the Manville B. Wakefield Memorial Award for outstanding contributions to the

preservation of local history by the Sullivan County Heritage Alliance in 1992.

He spearheaded Sullivan County's Stephen Crane '95 Festival to commemorate the local ties of author Stephen Crane on the 100th anniversary of the publication of Crane's most noted work, *The Red Badge of Courage*. He is a member of the board of directors of the Sullivan County Historical Society, a member of the Sullivan County Bicentennial Committee and is on the advisory board of the Catskills Institute.